IMAGES
of America

BENNINGTON

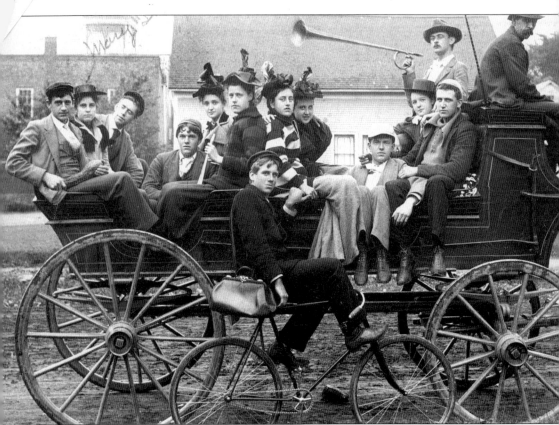

Headed to Sucker Pond for a picnic are (seated in the carriage) Elmer Ayres, Mary Shurtleff, chaperone Blanche Sibley, Joe Ayres, Eliza Abbott, assistant chaperone Mary Rawson, Louise Thatcher, Cynthia Gardner, James Donnelly, Louise Rawson, and George Donnelly. The Bennington Free Library is in the background. The little house directly behind the carriage on the corner of Silver and Union Streets was later moved to North Bennington.

IMAGES
of America

BENNINGTON

Bennington Historical Society and Bennington Museum

ARCADIA

Copyright © 2002 by Bennington Historical Society and Bennington Museum.
ISBN 0-7385-1027-0

First printed in 2002.

Published by Arcadia Publishing,
an imprint of Tempus Publishing, Inc.
2A Cumberland Street
Charleston, SC 29401

Printed in Great Britain.

Library of Congress Catalog Card Number: 2002106503

For all general information contact Arcadia Publishing at:
Telephone 843-853-2070
Fax 843-853-0044
E-Mail sales@arcadiapublishing.com

For customer service and orders:
Toll-Free 1-888-313-2665

Visit us on the internet at http://www.arcadiapublishing.com

CONTENTS

ACKNOWLEDGMENTS

For the Bennington Historical Society and Bennington Museum, this book was authored by Anne Harriss Bugbee, coordinating editor; Charles E. Dewey; Edward W. Dewey; Ruth Burt Ekstrom; Joseph H. Hall; Stephen Perkins, curator of the Bennington Museum; Beverley Petrelis; and Polly Wilson.

Without the help and generous contribution of time, information, and photographs, this book would not have been possible. We thank all of those who have generously shared their private photograph collections with us: Joseph Hall, Charles Dewey, and Edward Dewey for sharing not only their extensive collection but also the history surrounding the photographs; Beverley Petrelis for her postcard collection of Bennington; also Ellis Winslow, Gerald Wager, William McCoy, Robert Roy, Stanley Pike, Phil Pappas, Mary Mollica, Louise Himmelfarb, Violetta Santo, Ruth Ekstrom, Tordis Isselhardt, Jim Horst, Helen Holden, Gordon Lyons, Townsend Wellington, and Van and Ella Graves; and the Bennington Museum, especially Ruth Levin, registrar, who dug pictures out of storage, and Tyler Resch, museum librarian, who also provided us with photographs.

We express sincere gratitude to Dorothy Halvorsen for her willingness to type the manuscript, and to the Bennington Free Library for letting us meet in the Vermont Room on Thursday nights. A special thank-you goes to Stephen Perkins for directing the layout and editing the captions, and thanks also go to his assistants Polly Wilson and Beverley Petrelis for making things go smoothly. We have tried not to overlook anyone but if we have, it was not by intent and we offer our sincere apologies.

INTRODUCTION

Bennington is situated in Bennington County in the southwest corner of Vermont. Although chartered in 1743 by New Hampshire Gov. Benning Wentworth, who ignored New York claims to the land and named the area after himself, Bennington was not settled until 18 years later. The first settler was Capt. Samuel Robinson, a former Massachusetts militia officer who served in the French-and-Indian War. Robinson purchased the rights to most of the Bennington grants and with his family moved to the area in 1761. Within two to three years, he and the other proprietors formed a government that established a Congregational community based on ownership of land and participation in the only church in town. In the early years, settlers who belonged to other religious denominations were offered land owned by Robinson's sons in neighboring towns.

Life on the frontier was far from easy. Each day brought a new struggle against the wilderness and the elements. In addition to taming the wilderness, the settlers also had to contend with the claims of New York on their land. The town fathers, perhaps egged on by the oratory of Ethan Allen, formed a concerned citizens group named the Green Mountain Boys to protect the settlers' perceived land rights.

When the conflict between Britain and the American colonies erupted at Lexington and Concord, the Green Mountain Boys were available and ready to fight. Ethan Allen and Seth Warner became instant heroes when they captured Fort Ticonderoga without firing a shot. In 1777, the Battle of Bennington, fought just outside the town's borders, proved to be a major component of Gen. John Burgoyne's later defeat at Saratoga, "the turning point of the Revolution." The Bennington Battle Monument, completed in 1891, serves as a lasting tribute to Bennington's role in the fight for independence.

Although Bennington had mills in town from the beginning of settlement, most of the local industry developed rapidly in the 1800s. The number of mills reached its height just after the Civil War. The textile industry was an important mainstay of the town's economy, with mills such as Bradford's, Cooper Knitting, Rockwood's, and Holden-Leonard, among others. Other industries included gunpowder manufacture, shoemaking, ironworks, lumbering, papermaking, charcoal burning, and the famous potteries. With the mills came an influx of immigrant labor from places such as Quebec, Ireland, and Eastern Europe.

By the beginning of the 20th century, Old Bennington established itself as a summer community for the wealthy, many coming from the cities of Troy and New York. The Bennington Museum opened in 1928 for the preservation of the town's historical heritage. The

opening of Bennington College in 1932 brought a variety of individuals who contributed talents, such as dance, music, and the arts, to the community.

As the 20th century progressed, the mills slowly left town and Bennington had to change and evolve—as it will have to continue to do as the 21st century proceeds and the old ushers in the new.

No book can ever include all that an author wishes it to. The size of any book limits the range of material that can be included. This book provides an overview of Bennington, with an emphasis on the early- to mid-20th century and a preference for photographs that have not been previously published.

One

HOW WE LEARNED

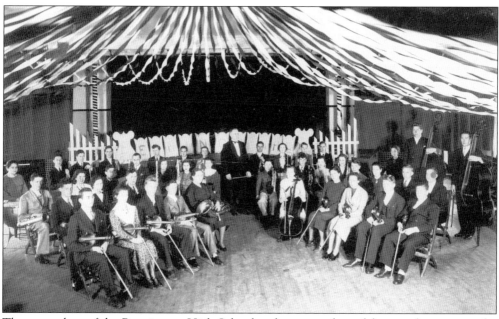

These members of the Bennington High School orchestra are dressed for a performance in the late 1930s. On the left are the following: (first row) William Walk, Dorothy Longtin, John Allen, Francis Brunina, and Theda Towsley; (second row) Joseph Comar, Freda Winn, Roger Stickle, and ? Levin; (third row) J. Bernard Harte, Stella Reynolds, John James, Charles Hubbell, Marado Goewey, Norma Margolin, and Bernice ?; (fourth row) Isabella Perrotta, William Hart, Sally Sullivan, Richard Firth, John McDermott, George Douglass, and Ruth Harrington. On the right are the following: (first row) Virginia Conroy, Esther Tinker, Jean Lawless, Arthur Murphy, and ? Harrington; (second row) Stuart Dumas, John Tinker, Margaret Keeler, Shirley Greenberg, Hinman Hawks, Agnes Cunning, Leonard Morse, and Joseph Carroll; (third row) Alden Harbour, Janet Small, Maurice Winn, and unidentified; (fourth row) Marjorie Dean, Ralph Quackenbush, and Howard Towsley. In the center is George H. Slater, director.

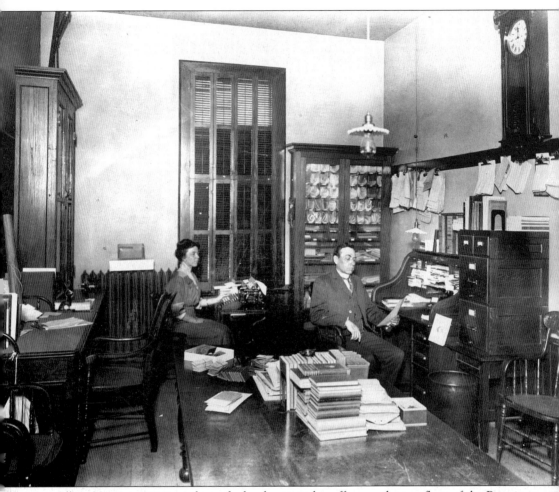

Albert Varney, superintendent of schools, sits in his office on the top floor of the Bennington Graded School in 1913. Bertha Lambert Burt, at the typewriter, performed all the secretarial work for the district and served as a substitute teacher whenever one was needed. (Courtesy of the Bennington Museum.)

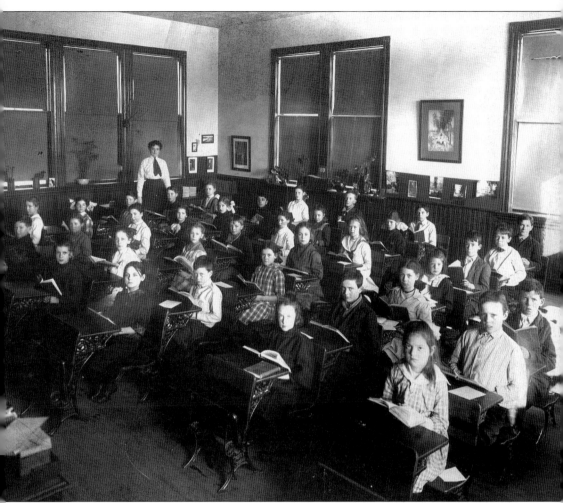

These pupils in Miss Hyde's fifth grade occupied Room 3 in the Bennington Graded School in 1914.

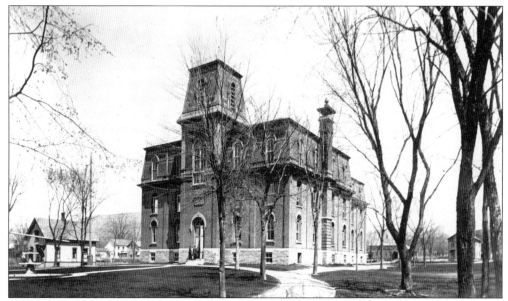

The 1870 consolidation of 20 school districts created the Bennington Graded School District. The Bennington Graded School, built in 1874, served all grades including the high school until 1913, when a separate high school was built. The Bennington Graded School was torn down in 1956.

Janet Shurtleff Dewey poses in front of the Bennington Graded School.

Seventh-grade students pose for an informal class picture in 1954. From left to right are the following: (first row) Pat Welch, Karen Miller, and Vicky Iskowitz; (second row) Jon Arnold, Stephen Rising, Frank Eaton, Stephen Rallis, ? Moffitt, Juleann Bushey, Sue Kunzelmann, and Marion Treeter; (third row) Charles Graham, John Marechal, David Wellington, Charles Dewey, Hal Searles, Joyce Rogers, Michelene Kloosterman, Lianne Savage, and Meredith Lloyd; (fourth row) Bob Plumb and Eugene Brown.

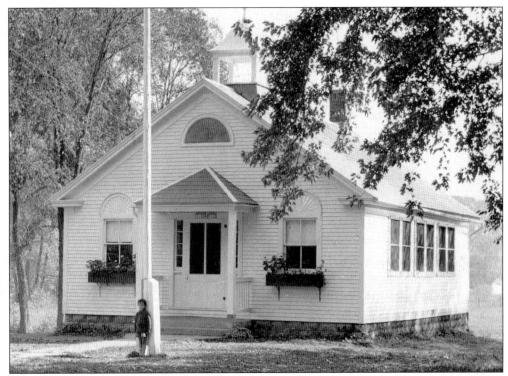

Shown is the Old Bennington rural school as it looked c. 1930. Small one-room schools like this served first- through eighth-grade students who lived too far from the center of town to attend the Bennington Graded School.

Students at the Old Bennington rural school pose with their teacher c. 1930. From left to right are the following: (front row) Elizabeth Heath, David Dennis, Sam Kelson, Edward Dick, Dorothy Powers, Betty Berry, Betty Miller, Polly Ridlon, and Bill Graham; (middle row) George Ogilvie, Orwin Coonz, Stewart Graham, Doris Campbell, Ruth Dick, Walter Berry, and Betty Holliday; (back row) teacher Drusilla Aiken, Joan Outhwaite, Salome Ross, Nancy Dennis, Jean Campbell, and Edna Loomis.

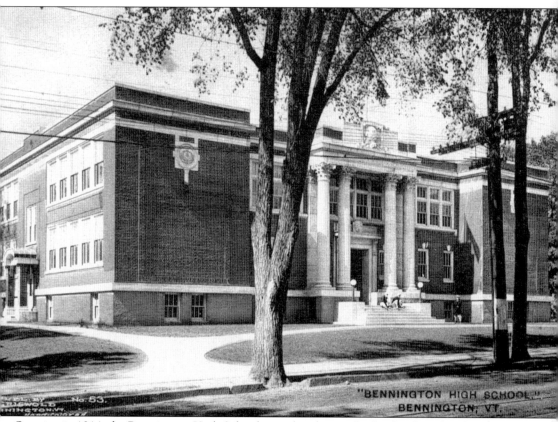

Opening in 1914, the Bennington High School served as the area high school until 1967, when it was replaced by the Mount Anthony Union High School. The old high school then became the Bennington Junior High School.

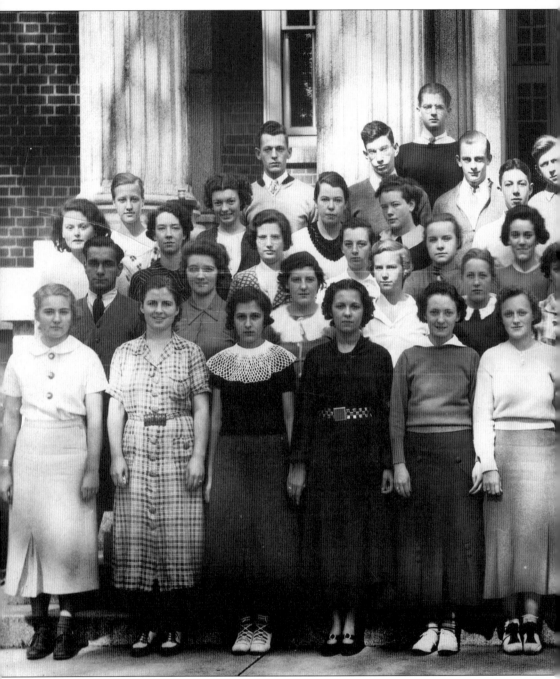

These Bennington High School students, from left to right, are as follows: (first row) Salome Ross, Ruth Harrington, Despo Pappas, Hazel Zobie, Dorothy Tetreault, Helen Green, Geraldine Carey, Marjorie Dean, Rachel Fowler, Rhoda Lyons, Stella Reynolds, Ruth Campbell, and Marie Fonda; (second row) Anthony Pello, Dorothy Longtin, Justin Sausville, Ruth Peterson, Mary Moon, Marado Goewey, Marian Barber, Bernadette McGowan, Betty Gifford, Freda Winn, George Douglas, and Anthony Devito; (third row) Ruth Pierce, Elizabeth Myers, Florence Clifford, Mary Judge, Martha McKerney, Frances Enright, Ethel

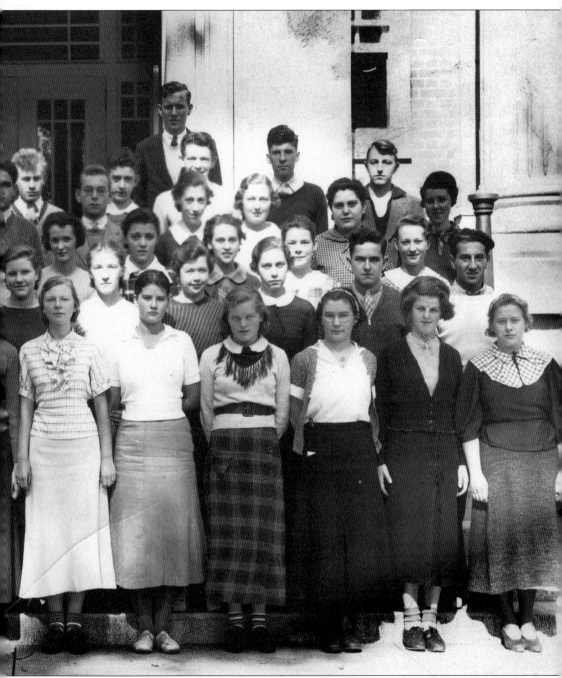

Vallencourt, Carol Rossiter, Jane LaCroix, Leona Sausville, Rena Bowen, and Eunice Sibley; (fourth row) Valieda Fleming, Leatrice Perry, Margaret Cunning, Betty Adams, William Hart, James Vince, William Walk, Florence Nevils, Opal Doherty, Isabella Perrotta, and Mary Dakin; (fifth row) Thomas Dunn, Howard Fitzgerald, Charles Hubbell, Kenneth Hill, Linton Tefft, Charles Morin, J. Bernard Harte, John Tinker, and Ronald Bennett; (sixth row) Alden Harbour and Henry Seymour.

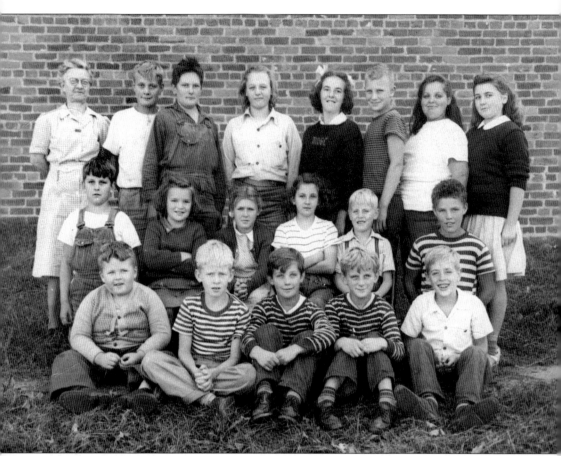

Taking advantage of a fine day is Bessie Farnham's class at the Harwood Hill School. From left to right are the following: (front row) William Keen, Robert Headwell, Leon Andrews, John Andrews, and Donald Dorr; (middle row) Kenneth Coonradt, DeeAnn Dickie Gauthier, Luella Chandler Stuart, Geraldine Clayton, unidentified, and Edwin "Buddy" Dickie; (back row) teacher Bessie Farnham, Roy Andrews, LeRoy Coonradt, Treesa Lorette, Margaret Dickey, John Hall, Barbara Andrews Jones, and Edith Keen Farley.

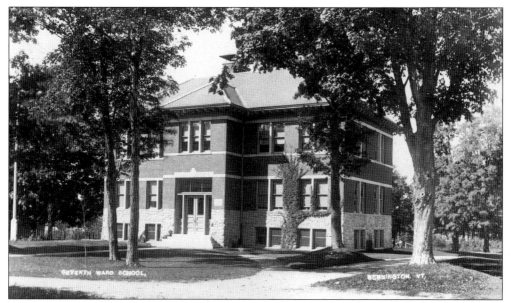

A growing population in the northeastern part of town led to the construction of the 7th Ward School in 1897 to serve primary grade students in that neighborhood. In 1919, the name was changed to the Cora B. Whitney School to honor the teacher and principal who served there for 30 years. The school was renovated and became a senior independent living center in 1999. In 2002, the building was placed on the National Register of Historic Places.

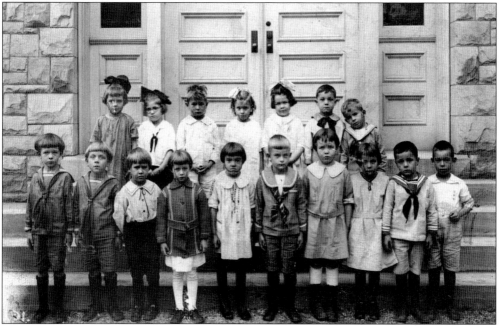

Kindergarten students proudly stand for their annual photograph in front of the 7th Ward School. From left to right are the following: (front row) Bernard Hill, Kenneth Hill, Leonard Cooper, Isabel Cutler, Leatrice Perry, Charles Hubbell, Betty Adams, and three unidentified students; (back row) Ruth Harrington, Ethel Vallencourt, William Walk, Marado Goewey, Betty Griffin, William Hart, and Robert Wilson. Annie Dakin is their teacher.

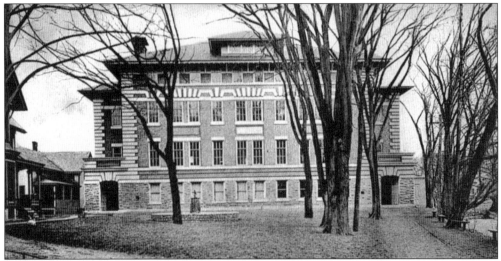

St. Francis de Sales School (pictured) was, along with the Sacred Heart School, one of two parochial schools serving elementary pupils in Bennington during much of the 20th century. The Bennington Catholic High School operated briefly, from 1956 until 1967.

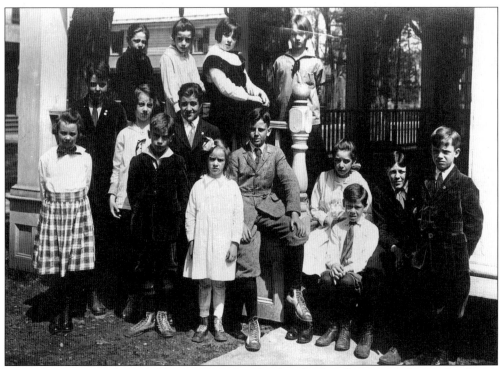

Some families sent their children to private schools. The best known of these schools was operated by Maud Carpenter. Shown at the school, from left to right, are the following: (front row) Estelle Bennett, Charles Bennett, Helen Cushman, John Holden, Harry Cole, Julianna Holden, Dick Holden, Kay Booth, Breard Hawks, Van Graves, and Townsend Wellington; (back row) Buddy Kellogg, Nora Booth, Ruth Kellogg, and Betty Cushman. (Courtesy of Townsend Wellington.)

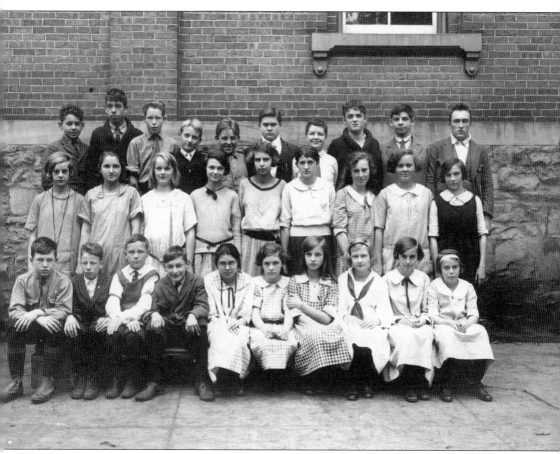

Students posing in front of the Bennington Graded School in 1923, from left to right, are as follows: (from rear) Ernest ?, Edward Flynn, Raymond Cobb, Arthur Dewey, Milton Bahan, Lawrence Gammell, Frank Beecher, Howard Brower, George Chartoff, Leah Cook, Glina Chambers, Olive Gavin, Barry Cushman, Verna Carrier, Marie Cosgrove, Helen Clark, Ella Fitzgerald, Estelle Bennett, Jane Blanchard, Jack Gibson, Hector Colvin, Charles Bodine, George Fienberg, Mary Barber, Bernice Cronin, Dorothia Eldred, Lillian Cook, Marjorie ?, and Helen Atwell.

Since its opening in 1932, Bennington College has been a center for the fine and performing arts, attracting many well-known artists, writers, actors, and dancers to the community. A few of these include writers Bernard Malamud, Shirley Jackson, Stanley Edgar Hyman, and Jamaica Kincaid; poet Ben Belitt; artists Paul Feely and Helen Frankenthaler; and dancers Martha Graham and Bill Bales.

Lots of learning has taken place in the Bennington Free Library's Silver Street building, which opened in 1936 to replace the older library on Main Street. Today, the two buildings have been joined to serve the growing needs of the community.

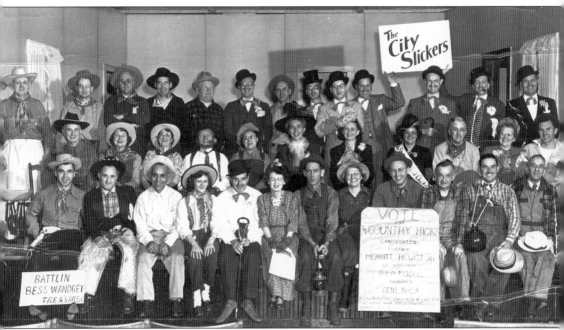

Graduates of the Dale Carnegie Public Speaking School enjoy their success with much tomfoolery. From left to right are the following: (front row) Bob Roy, Dr. Francis Tomasi, Jim Playotes, Caroline Ahearn Parker, unidentified, Bernice McMahon, James Kelly, Daisey Myers, unidentified, Gene Shea, Merritt Hewitt Jr., Dr. Fred Wandrey, and D. Edward Moore; (middle row) Ray Quinlan, Elizabeth Armstrong, Bess Wandrey, unidentified, Yvonne Lampron, Mabel Quinlan, Betty Kelly, Peggy Maclay, unidentified, Florence Hadwen, and George Hadwen; (back row) unidentified, Richard Crozier, Bob Holden, Jack Clawson, Dan Keeler, Frank Poulton, unidentified, Ken Clayton, unidentified, Jim Nelson, two unidentified people, and Carl "Curly" Williams. (Courtesy of Phil Pappas.)

Two
HOW WE LIVED

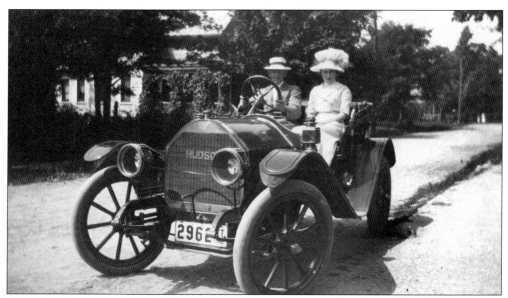

Chelsea Harrington, driving his 1910 red Hudson, courts Edith Lyons. The couple married in October 1912 and resided on Safford Street.

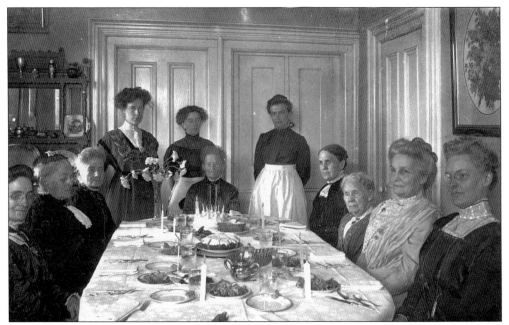

This birthday tea party was for women only. All the linens are made from expensive damask material. The sideboard displays family silver, and a framed needlepoint piece hangs on the wall. Irene Thatcher, in a light dress, sits next to Jennie Valentine. Mrs. Edward Norton (fourth on the same side) is also enjoying the party.

Ruth Burt Ekstrom plays tug-of-war at her birthday party in July 1938. On the right are Louise Betit Johnson, Rose Betit, Barbara Petrelis Cornell, Shirley Comstock, Ruth Burt Ekstrom, Ann MacLaren Cathcart, Beverley Petrelis, and unidentified.

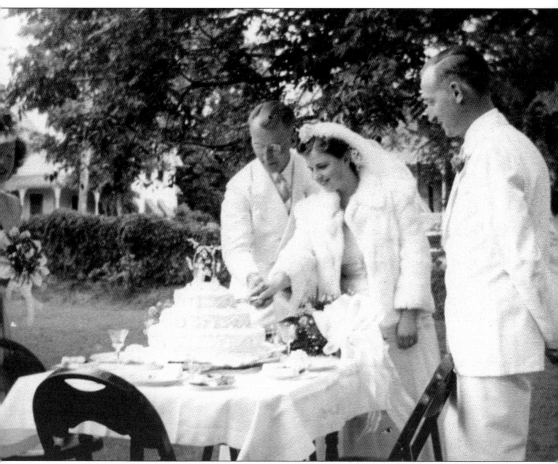

Arthur Dewey and Ruth Harrington were married in the Lyons garden at 800 County Street on August 24, 1940. The day was so cold that the bride wore a fur jacket. Lois Harrington and Charles Dewey watch the bride and groom cut the cake.

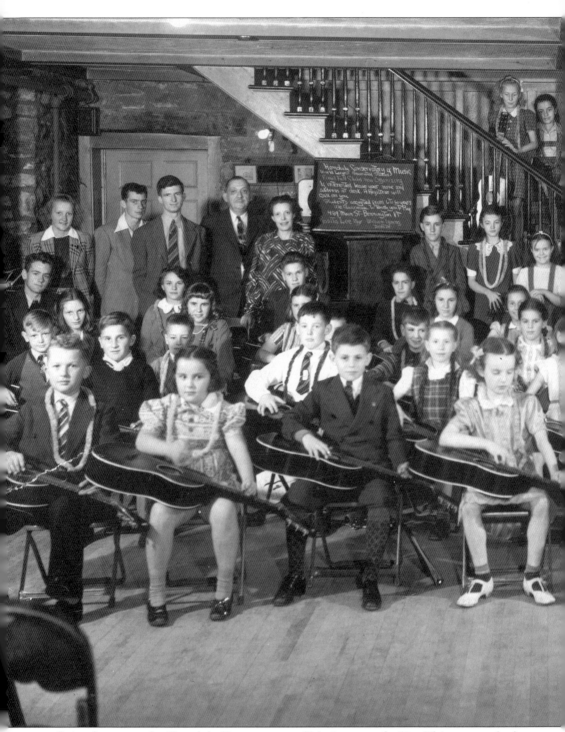

Guitar lessons at the Honolulu Conservatory of Music cost only 50¢. This was much cheaper than piano lessons, which cost $1 to $2. Guitar students are ready to perform in the 1942 recital held in the Bennington Girls' Club, the stone building on the corner of South and Elm Streets. Among those on the floor are Pat Pinsonneault, Dick Garrant, Joe Sourdiffe, Elaine Thurber,

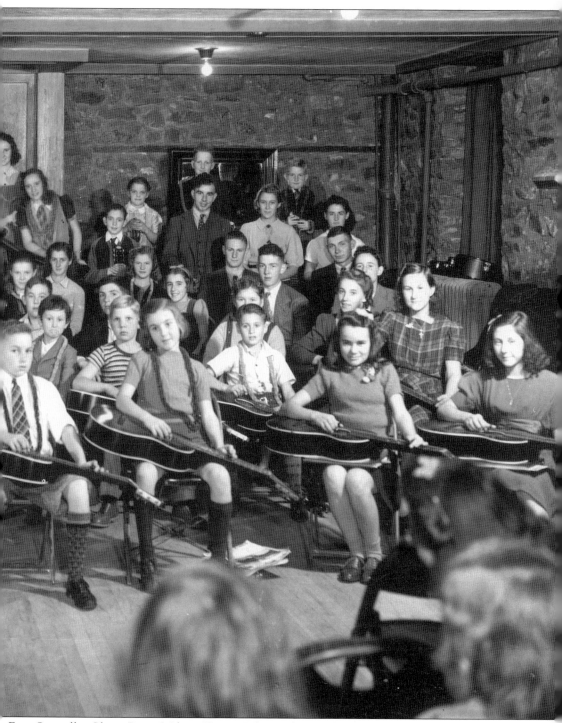

Fran Sausville, Claire Betit, Milton Hattat, John Malone, Olive Harrington, Lorraine Cross, Lorraine Gates, Grace Howe, Jackie Howe, Diane Roy, Barlow Thomas, Ida May Foster, Dorothy Mattison, and Elizabeth King. Among those on the stairway are Marie Hadwen, Barbara Petrelis, and Beverley Petrelis.

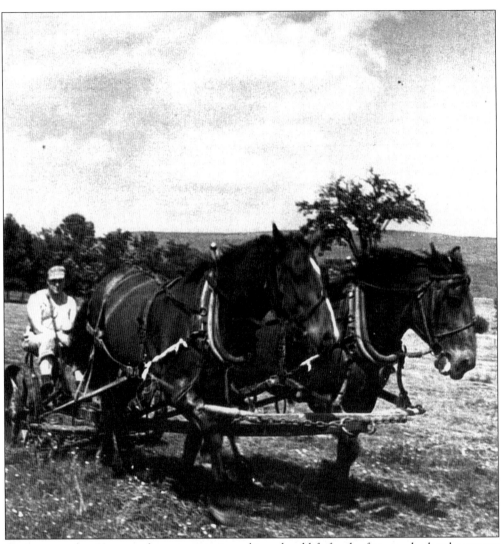

A picture perfect Vermont farm scene is, in reality, a hard life for the farmer who battles nature daily. The dust and heat endured during haying season is not apparent in this photograph. It was not many years ago that horses were still used in the hayfields around Bennington.

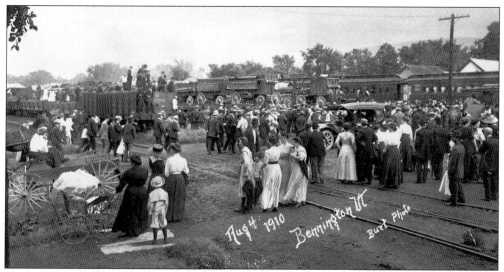

The circus comes to town. On an August morning in 1910, townspeople gather at the station on Depot Street to watch the circus train unload. In the left foreground is an elaborate baby stroller, complete with ruffled parasol.

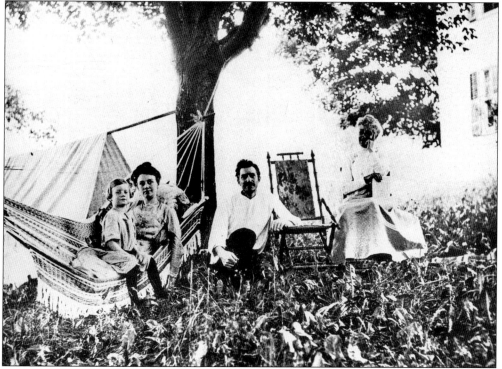

Members of the Hinsdill family sit in the yard of their house on Harrington Road in North Bennington. Roger Hinsdill and his mother, Aimee Hinsdill, share the hammock. Behind them is a play tent, constructed by throwing a bed sheet over a rope. Charles Hinsdill, the father, and his mother, Mary Henry Hinsdill, complete this tableau of mothers and sons. (Courtesy of Louise Himmelfarb.)

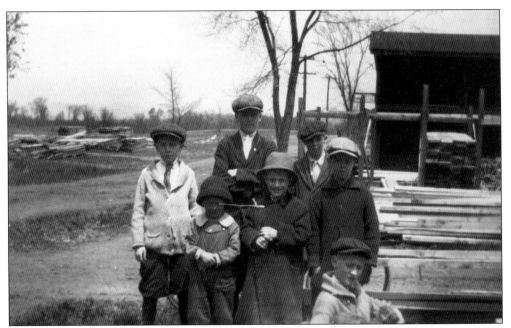

These youngsters are standing in the Dewey Lumberyard on McKinley Street, about where Adelphia Cable and the Bennington Rescue Squad garage are located today. From left to right are Bob Holden, unidentified, Art Dewey, Mark Tripp, Tony Sibley, and Charles Dewey (seated).

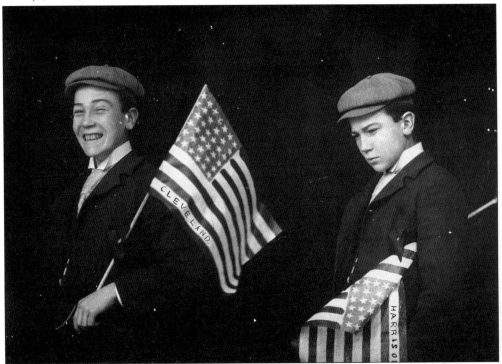

One boy appears as two in this trick photograph, used to express political reaction to the election of Grover Cleveland. The candidates' names were added after the picture was taken.

Camping was a popular activity in the early 1900s. Pictured camping in Glastenbury are Ralph Burt, Sidney Burt, Elmer Summersgill, and two Petersons—father and son.

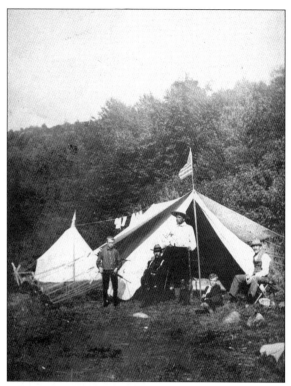

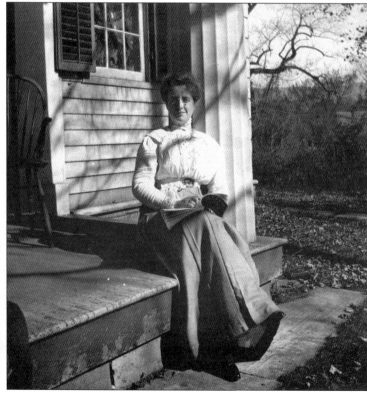

Edith Dewey sits reading on the porch of her house on Main Street, c. 1910. Cool Vermont summer evenings often lure residents to their piazzas or porches, but at dusk mosquitoes drive them back indoors.

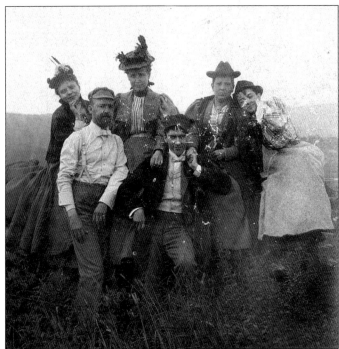

Picnics and day trips were popular with the younger generation. Among those enjoying a day in the country is Daisy Smith Bradford (far right), wife of W.H. Bradford.

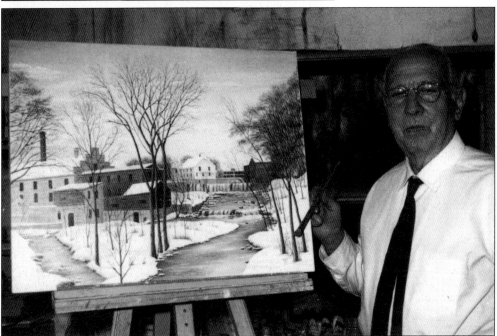

Patsy Santo, the self-taught landscape artist who was a house painter by trade, was born in Italy but lived in Bennington for many years. Within his lifetime, he became an artist of renown. He was discovered in 1937 by Walt Kuhn, a noted New York artist, who arranged for Santo a one-man show at the Marie Harriman Museum of Art in New York City. Of the 45 paintings on exhibit, 33 sold. The painting on the easel is of Paran Creek and the North Bennington mills. (Courtesy of Violetta Santo.)

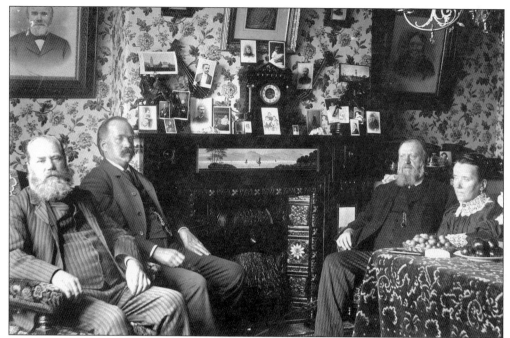

In 1901, after the deaths of Amos and Maria Tiffany, family members met to discuss the estate, including Amos Tiffany's share of the Tiffany Mill. From left to right are Frank Tiffany, Eli J. Tiffany, Martha Moorehouse, and her husband. This picture reveals the elaborate clutter of Victorian parlors.

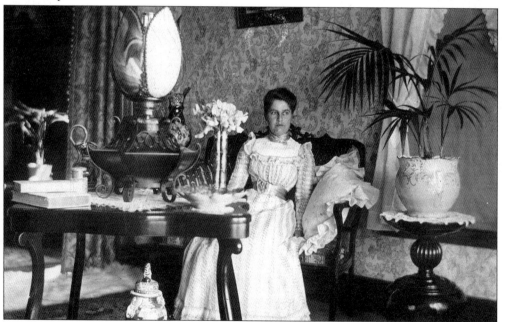

Shortly after her marriage, Mary Shurtleff Rockwood sits poised in the front parlor of her home at 109 Branch Street. Her husband, Arthur Rockwood, owned the Rockwood Mills on East Main Street (the foundation remains visible today). Notice the large lamp in the middle of the table.

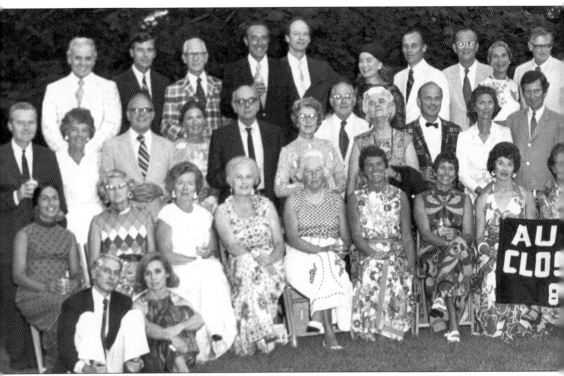

A party to say farewell to Whit Dickey as he left the Catamount (now Merchants) Bank for a new job was hosted in 1973 by his friends. From left to right are the following: (first row) Arnold Ricks and Pat Adams; (second row) Linda Tilgner, Betty Clark, Barbara Wellington, Billie Cushman, Ella Graves, Catherine "Cappy" Cumpston, Closey Dickie, Barbara Geer, Jean Rice, Ginger Gilman, Emily Hall, Marge Lapham, Gertrude Hamlin, Ruth Dewey, Priscilla Baxter, and Elaine Whitten; (third row) Charles Tilgner, Dot Aja, Townsend Wellington, Alison White, Hall Cushman, Betty Giddings, Van Graves, Libby Holden, Whit Dickey, Joy

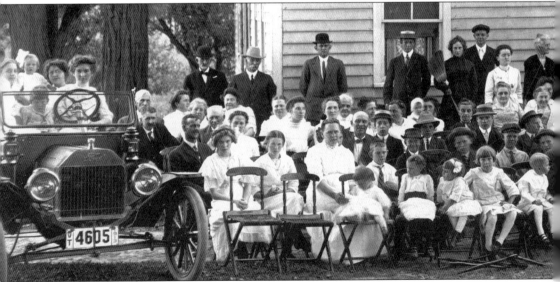

The Strattons hold a family reunion at the Stratton farm on the East Road. Even the

Bushman, Dan Geer, Wilbur Rice, Steve Gilman, Jean Leake, Tom Hall, Gene Irons, Walt Lapham, Emmely Parks, Jean Hamlin, Mimi Wilson, Arthur Dewey, Stowell Baxter, Robert Wilson, Marshall Whitten, Terry Parks, Mickey Hawks, Gerry Baker, Breard Hawks, Gene Clark, and Dudley Baker; (fourth row) Ray Aja, Terry White, Phil Giddings, Harry Cumpston, Michael Reinhart, Sheila Reinhart, Tom Bushman, Fabian Kunzelmann, Helen Kunzelmann, Dick Leake, John Irons, Tony Parks, Lucy McKee, Lulie Laris, Jim Toolan, Helene Toolan, and Joe Parks.

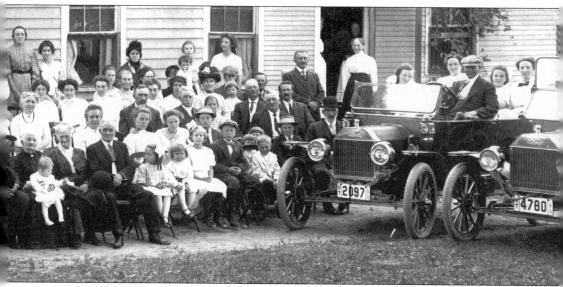

automobiles are included.

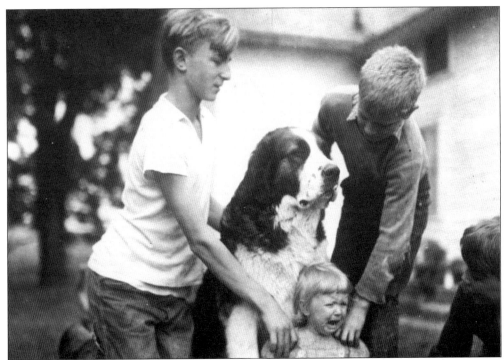

Settling the children for a family photograph can be a very frustrating experience. The Hall children are an example of this, as their father tries to get them in order for a portrait in 1946. From left to right are Joe Hall, about age 14; Butch Hall, the family's St. Bernard; Harriet Hall, now Harriet Beattie of Lancaster, New Hampshire; John Hall, now of East Montpelier; and Phil Hall, now of Florence, Massachusetts.

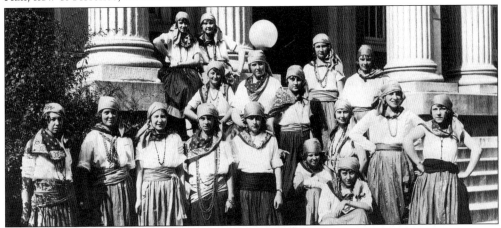

The label on the back of this picture reads "Giving Our Services as Modern Health Crusaders, Summer 1925." In gypsy costume, these young women assemble on the steps of Bennington High School on Main Street (now Bennington Middle School). From left to right are the following: (front row) Ann Gaul Couch, unidentified, Irene LaFlamme, Priscilla Bromley Norton, Marjorie Eddy, Anna Chase, Mary Louise Plumb, and unidentified; (middle row) Doris Hart, Harley Armstrong, Elsie Sloat, Elizabeth Armstrong, and Bernadette LaFlamme; (back row) unidentified, Doris Harbour, Mildred Hart, and unidentified. (Courtesy of the Bennington Museum.)

Three
HOW WE WORKED

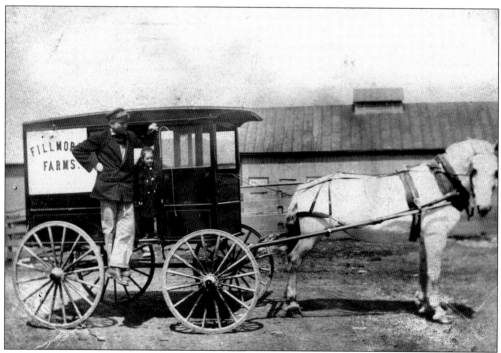

Fillmore Farms Inc. used horse-drawn delivery wagons, but its dairy-processing plant was not within practical distance from town for horses. The horses stayed in town, and the dairy products were delivered to them by truck. John Freitag stands on the steps of his milk wagon. When this photograph was taken in 1909, James C. Colgate of Bennington and New York City owned Fillmore Farms. (Courtesy of William McCoy.)

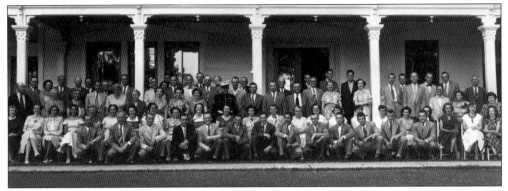

In 1946, Fillmore Farms was sold to the employees and the name was changed to Fairdale Farms. This gathering of Fairdale Farms employees was held on June 21, 1951, at the Country Club (the former Clark house), which burned in 1957 or 1958. From left to right are the following: (first row) Ken Worthington, Bob Holden, Joe Hall, Ralph Philpott, Francis Humphries, John McNeilly, Dick Rabideau, Tom P. Kinney, Leo Bentley, Bob Kinney, Dave McNeilly, John Harris, Ken Percey, Hazel Hart, Laura Freitag, and Doris Kinney; (second row) Mary Hall, Mary Frances Murphy, unidentified, Salle Baker, Lida Mattison, Ruth Holden, Beryl Bentley, Lorrina Abrams, Alva Bodine, Rose Philpott, Trudie Kinney, Rachel Kinney, Barbara Breese, Donald Boutin, Helen Boutin Wiggin, Joan Kinney, Claire Lorom Turner, Joyce Harris, unidentified, Angela Percey, Maurice Douglass, Dorothy Douglass, and Marjory Blake; (third row) John Campbell, two unidentified people, Floyd Mattison, Anna Towslee, unidentified, Beatrice Worthington, Mary Boutin, Irene Betit, Jim Kinney, Francis Kinney, Bob Breese, Bill Blake, Don Hart, John J. Freitag, and veterinarian Dr. Illingsworth; (fourth row) Leon Percey, two unidentified people, Merritt Hewitt, Edward Knott, Shirley Hewitt, Joe Towslee, Henry Boutin, Eva Wolfe, unidentified, Hector Betit, Charlie Bodine, unidentified, Tom E. Kinney, Jenny Freitag, George Dick, John P. Freitag, John Osgood, Dick Baker, Tom Murphy, and Jim Holden.

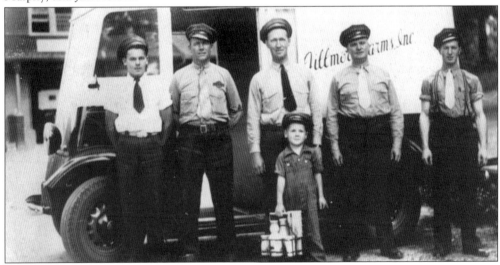

The building in the background, now the Bennington Bus Terminal, was the horse barn and terminal for Fillmore Farms. When this photograph was taken c. 1939, the horses had just recently been retired and trucks were put into use. The men, from left to right, are Edward Worthington, Ed Comstock, Joe Towslee, Les Mort, and Ellis Winslow. The boy is James Holden. (Courtesy of William McCoy.)

Albert Horst, showing off his milking machine in 1944, stands in front of the milk house at his farm on Pleasant Valley Road. (Courtesy of Jim Horst.)

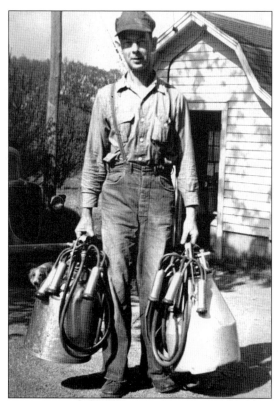

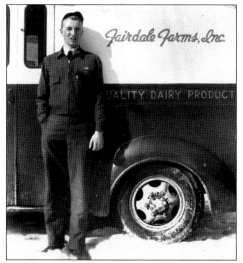

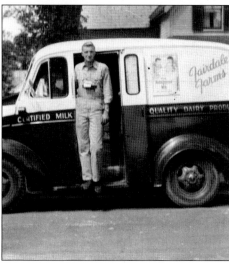

Joe Hall (left) stands in front of his Fairdale Farms milk truck. When he started with the company in 1951, there were 12 retail milk routes. Milk was delivered every other day by six drivers. Each driver had two routes, one day off per week, holidays only if they fell on the day off, and one week of vacation per year. Wages were $10 per week, plus seven percent commission on the money collected from sales. Joe Hall (right) is pictured in 1955 wearing the all-purpose checked denim uniform that replaced the winter wool and the summer cotton uniforms. The lettering on the side of the truck has become more ornate. Delivery is now three times per week, and vacations have been extended to two weeks per year.

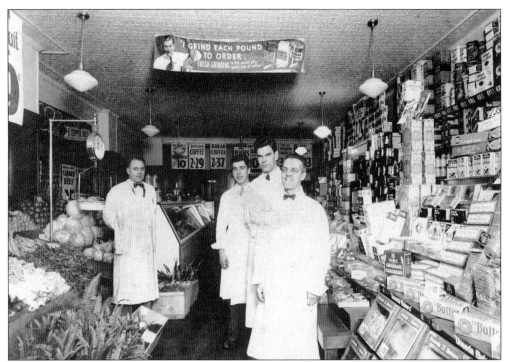

Employees of the A & P, located at 126 North Street, stand by ready for business on August 20, 1938. Pictured are store manager John Connell, clerk Robert Roy, meat manager Dick Bradway, and Fred Pellerin. (Courtesy of Robert Roy.)

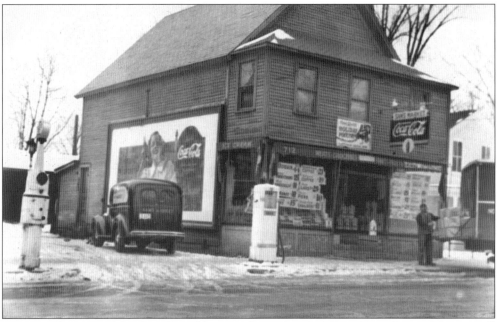

Sam's Market, owned by Sam Trombley, was located at 712 East Main Street. These small "corner" markets often defined neighborhoods. A few still remain and maintain their role of neighborhood information centers.

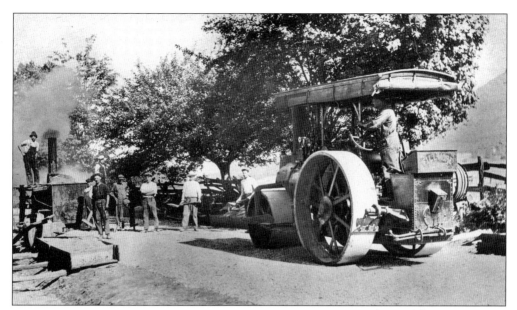

This steamroller and its crew are building a railroad siding for James Colgate near the intersection of the West Road and the railroad tracks. This paved road allowed easy delivery of coal to Ben Venue, Colgate's summer home on Mount Anthony. Colgate was also responsible for getting the road paved between Fillmore Farms and Old Bennington.

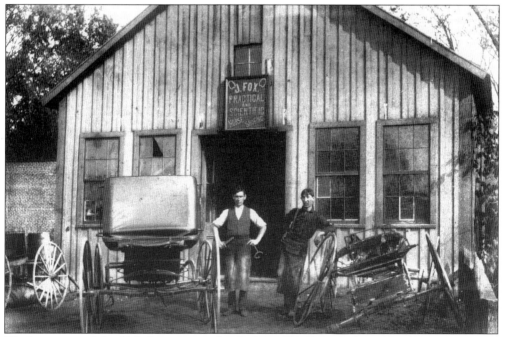

The beginning of the 20th Century saw the decline of blacksmith shops like this one on Depot Street. Notice the sign, "J. Fox, Practical and Scientific Horse Shoeing." The Smithy stands holding the tools of his trade, arms akimbo, looking dark and handsome.

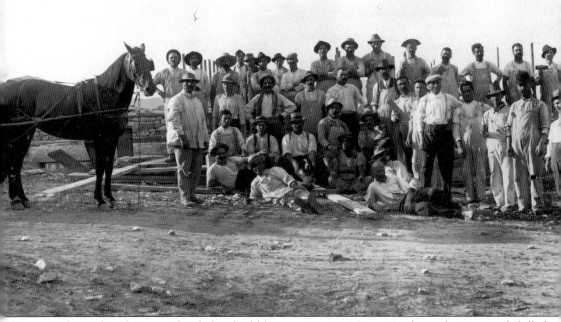

When Edward Everett decided to build his mansion on Mount Anthony, he imported skilled masons from Italy to work the stone. Many of these stonemasons remained in town and, within a generation, were active contributors to the community.

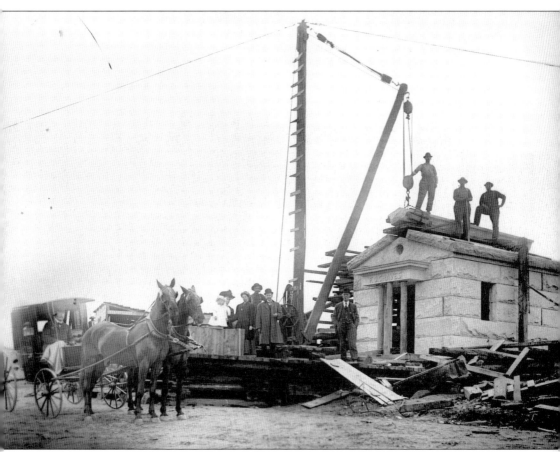

Frederick Graves (in the buggy) and other family members watch as the capstone is placed on the family mausoleum in Park Lawn Cemetery.

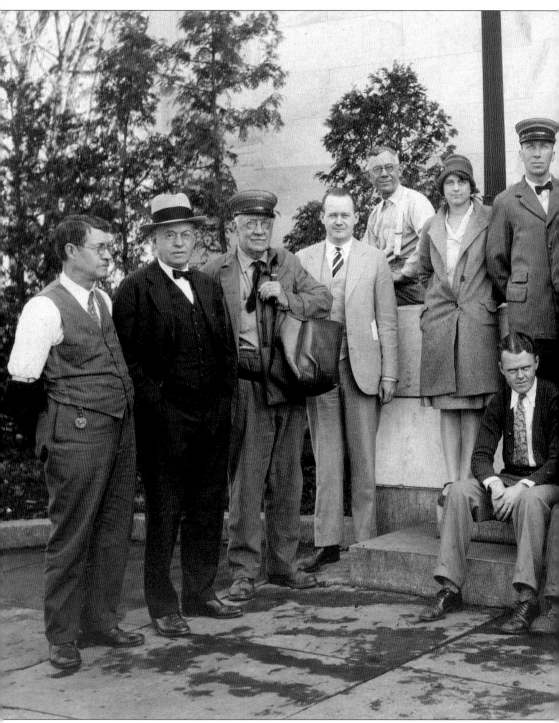

In 1929, the employees of the Bennington Post Office pose on the steps of the new post office building (now the Bennington Police Station) on South Street. From left to right are the following: (front row) Thomas "Twink" Toomey, Bernard Ryan, Harold Peart, and Earl Hurley; (middle row) Herbert Armstrong, Frank E. Howe (postmaster), John Haley, Bill Hurley, John

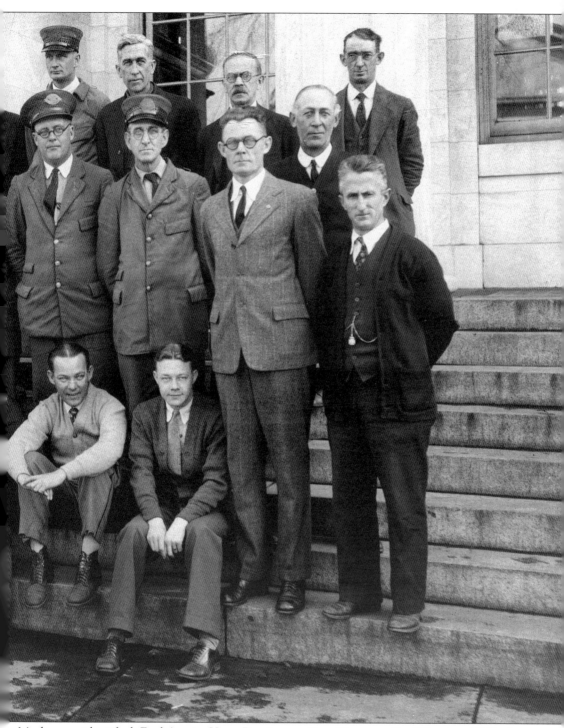

Mayhew, unidentified, Fred Austin, Harry Remington, Tom Donovan, Fred Harmon, Walfred Walquist, and Lynn Wood; (back row) George Rice (rural), Sam Patterson, William Percey (rural), Opie Harwood, Turner Cranston, and Clarence Morse (rural). (Courtesy of Mrs. Edward Bronson.)

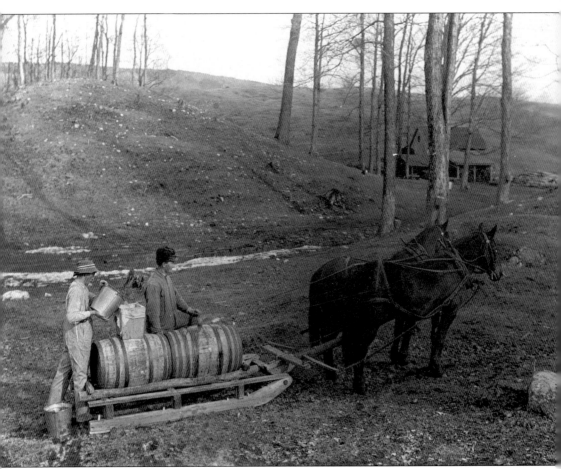

Although there are only traces of snow, these two men gather sap and pour it into barrels, that are strapped to the sled. Some sap buckets can barely be seen hanging from the nearest maple trees. Scenes like this have vanished as, today, the sap is gathered through long tubing into a central holding tank.

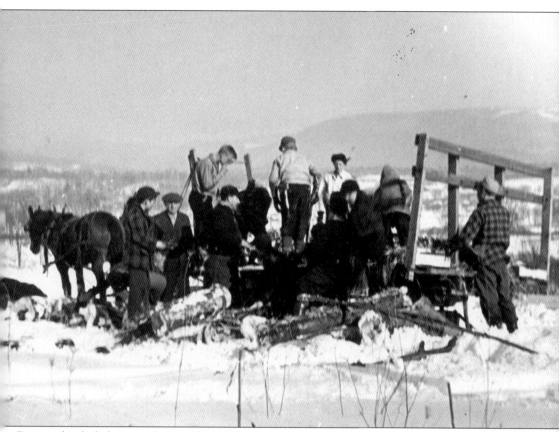

Due to the fuel shortage during World War II, boys from Bennington had to gather wood to heat the Young Men's Christian Association (YMCA) building on Main Street. The Y provided a number of activities for the youths of Bennington and their families.

This view of Benton Pond shows the rear of the Cooper Machine Works on East Main Street at the corner of Beech Street, a large employer in town. The dirt road on the left is Morgan Street. Benton was one of two large natural ponds in town that supplied waterpower for the mills. Little remains of it today other than a swampy area.

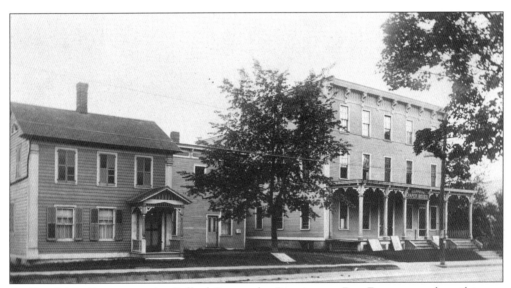

On East Main Street opposite Safford Street, the Bennington Box Factory stood until it was demolished in the 1960s by order of the selectmen. Stewart's Convenience Store now occupies the space. The little house on the left still stands.

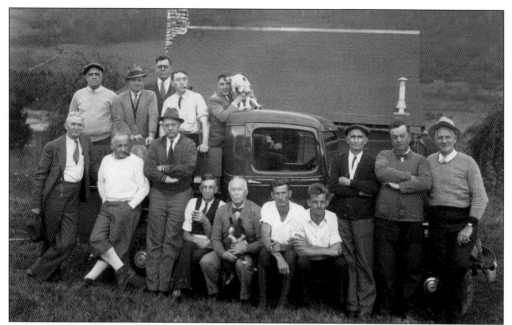

Employees of the Bennington Water Department pose at their annual dinner held in October 1936. From left to right are the following: (front row) D.J. Lawless, Dan Sargent, Haviland Sibley, H. Breese, Dr. Lucretius Ross, William Braisted, Grover Lyons, William Hogan, and Wills White; (back row) Raymond Howard, Roy Paddock, and Halsey Cushman, holding on to the dog.

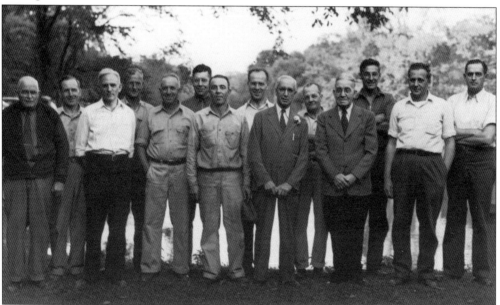

Cushman Furniture Company in North Bennington was known for its distinctive Colonial Creations line. This group of workers is gathered to honor Bert Bromley for his 50 years with the company. From left to right are Walter Whitman, Harold Elmer, three unidentified men, Ben Gauthier, Harold Reimann, Bert Bromley, Glenn Ayer, ? Rourke, Carl Jolivette, Joseph Keene, and Grange Lape.

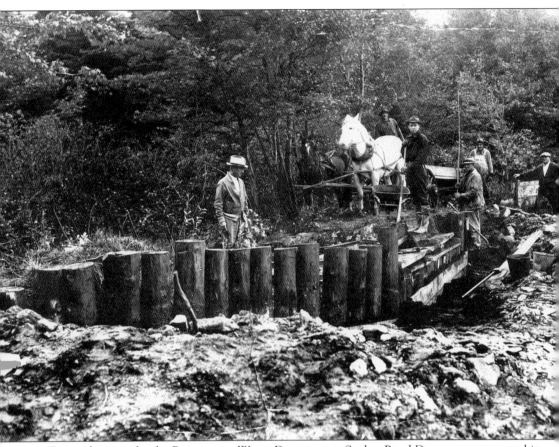

To supply water for the Bennington Water Department, Sucker Pond Dam was constructed in 1939. From left to right are water commissioner Wills White (wearing a light-colored hat), Robert Purdy (with the shovel), Charlie Hicks, boss Everett Lillie, Ralph Lillie, and cook Henry Pratt. A road had to be hand cleared in order to allow the wagon access to the work area. (Courtesy of Robert Purdy.)

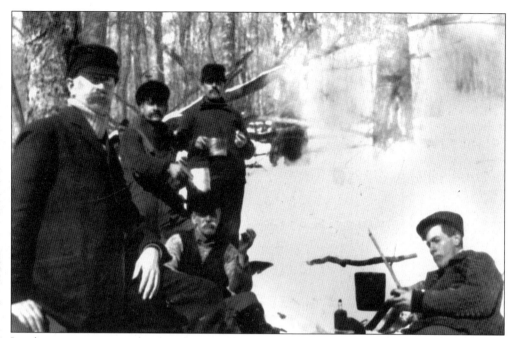

Lumbering was a major business in Bennington in 1906. Arthur J. Dewey (left) takes a break with his loggers ? Marra (standing), unidentified, and James and Elmer Dinwiddie (seated). Note the pot cooking over the open fire.

On April 14, 1912, Bennington resident Charles Cresson Jones lost his life in the sinking of the *Titanic*. Jones, general manager of James C. Colgate's 4,000-acre Fillmore Farms, was a highly respected breeder of various kinds of livestock, especially sheep. When Jones's body was recovered off the coast of Halifax, Colgate, as a sign of his respect and affection, had it returned to Bennington and buried with full honors in the cemetery in Old Bennington. (Courtesy of Alex Mahar.)

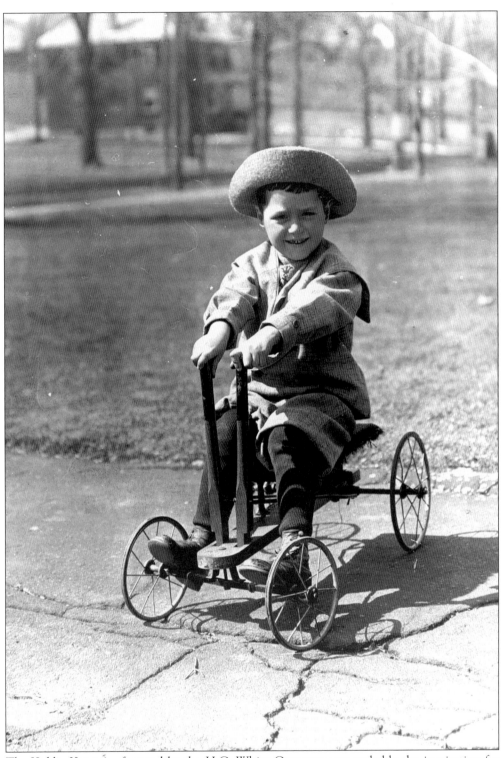

The Kiddie-Kar manufactured by the H.C. White Company was probably the inspiration for this pedal car. Its success can be judged by the smile on the boy's face.

Four

HOW WE TRAVELED

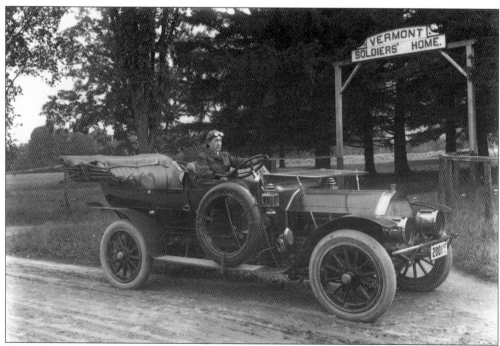

An unidentified driver poses in a 1910 Peerless in front of the Vermont Soldiers Home on Hunt Street. The automobile probably belonged to Gov. John McCullough.

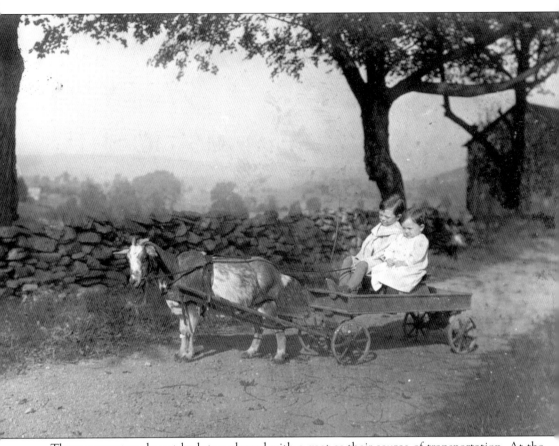

These youngsters do not look too pleased with a goat as their source of transportation. At the beginning of the 20th century, a popular fad among the more affluent was to have goat and dog carts for children's use.

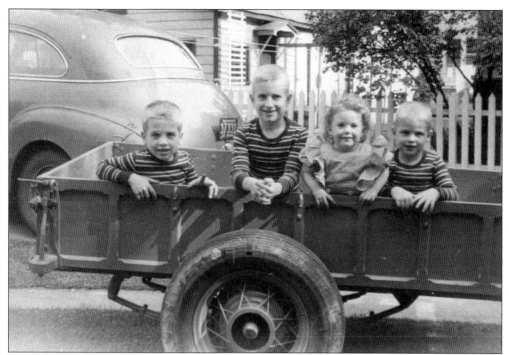

Charles, Jed, and Phil Dewey, and Lois Banulis grin happily from the bed of the trailer owned by their grandfather Chelsea Harrington. Trailers like this one were attached to the rear of the family sedan, turning it into a utility vehicle.

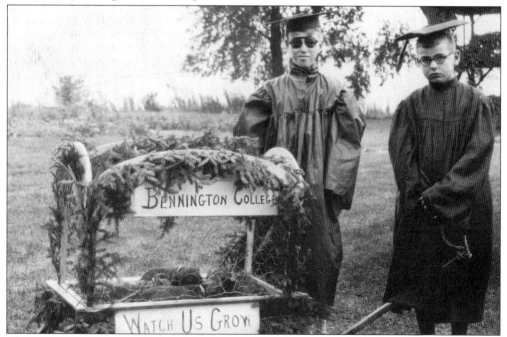

This little wagon was used to publicize the birth of Bennington College at a street fair in Old Bennington in 1926. Adorned in cap and gown, Carson Small (left) and Homer Harrington watch over the puppies that are asleep in the wagon bed.

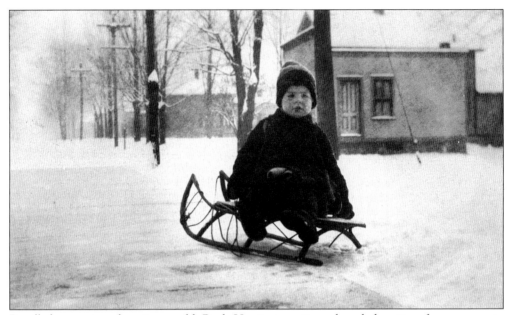

Bundled up against the winter cold, Ruth Harrington sits on her sled waiting for someone to give her a ride. Note the 1920-style runners with their high points in the front.

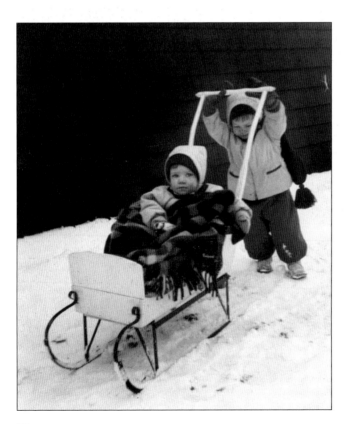

Linn Wilson pushes her brother Dale Wilson in their great-grandmother's sled in 1952.

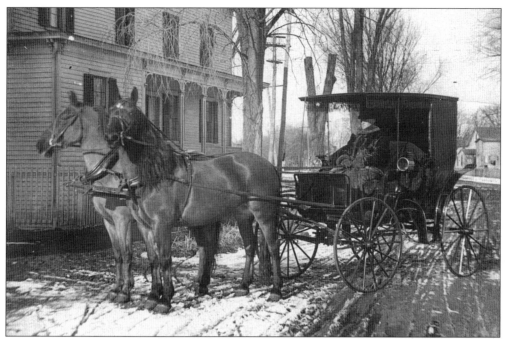

These two horses pulling a rockaway carriage do not seem to be bothered by the snow or the muddy ruts of the street. The owner, wrapped in fur, is protected from the winter chill.

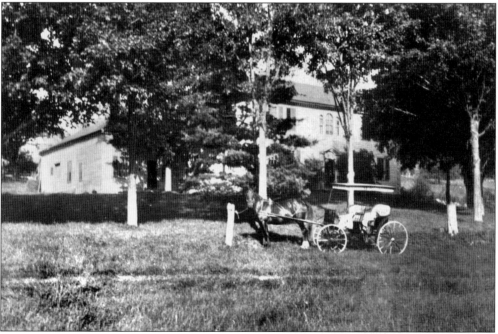

Tied to a hitching post, this horse waits patiently for his passengers to fill the carriage. Located on Harrington Road, the house is the Hinsdill House. It was designed by Lavius Fillmore, better known for his churches including the Old First Church in Bennington. In the early 1800s, Fillmore designed several houses in the Bennington area, recognized by their Palladian windows. (Courtesy of Louise Himmelfarb.)

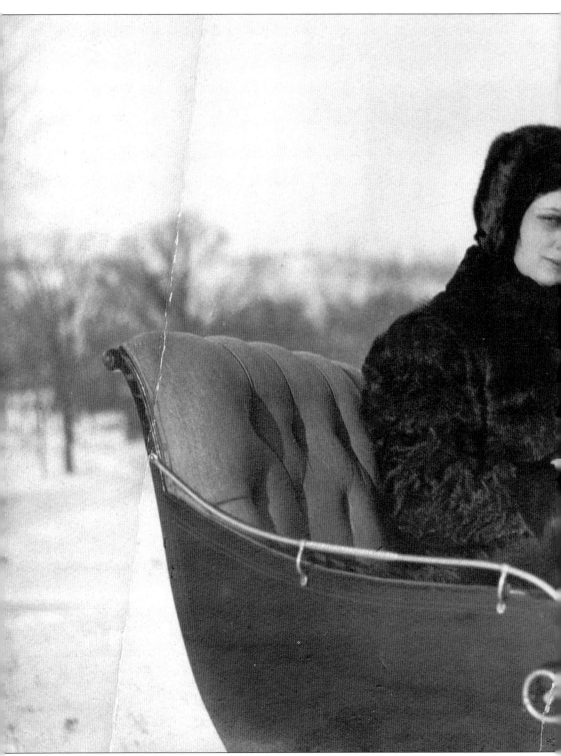

The horse-drawn sleigh was an important method of transportation in 1908 before the advent of modern snow-removal equipment. Caroline Eliza Cushman of North Bennington creates a

Christmas-card image in her furs and elegant sleigh. (Courtesy of Townsend Wellington.)

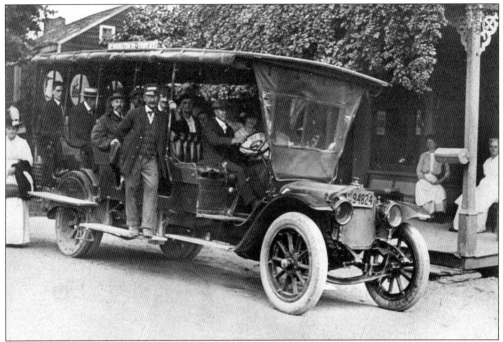

Local bus driver Everett O. Wager Sr. launched his Bennington–Troy bus line with this 25-seat bus-car in 1915. Everett Wager sits at the wheel, while his father, Delbert Wager, a former stagecoach driver, stands on the running board. When this photograph was printed in the *Bennington Banner* in 1958, the company had been in operation for 43 years. (Courtesy of Gerald Wager.)

The Bennington–North Adams trolley line ran between the Middle Pownal Road and Morgan Street, behind the Louis Briggs house, later the home of Dr. Browning and Phil O'Neill. It is likely that there was a ticket office in the ell of the house.

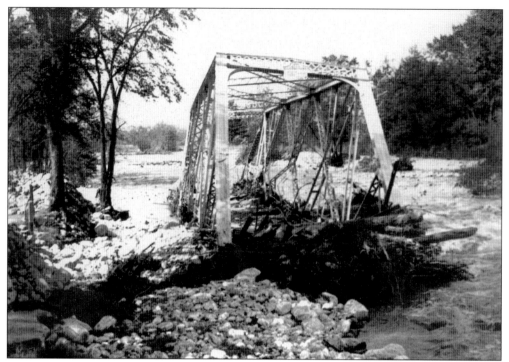

The flood of 1938 caused severe damage in Bennington, as seen in this view of the bridge on Park Street. The bridge spanned the Roaring Branch River, which lived up to its name with a vengeance.

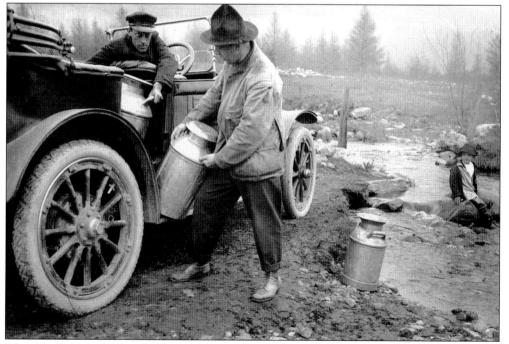

John Patterson and Edward Whitney stock a stream with trout. In 1914, the trout were carried in milk cans and dumped into the stream.

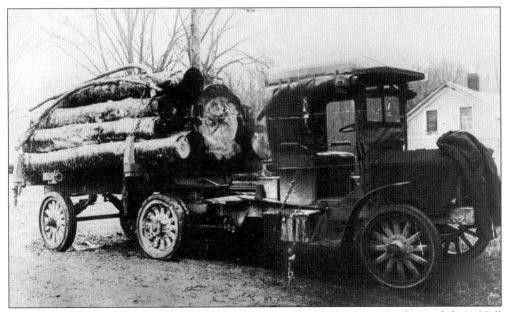

H.T. Cushman and Company, furniture makers, used trucks to carry birch wood from Hell Hollow (Harbour Road) in Woodford to its plant in North Bennington. The side curtains on the cab offered some protection against inclement weather, and the blanket over the hood kept the motor warm.

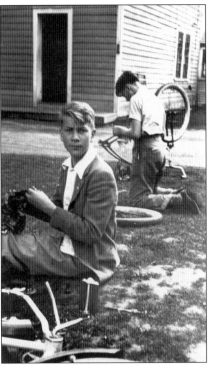 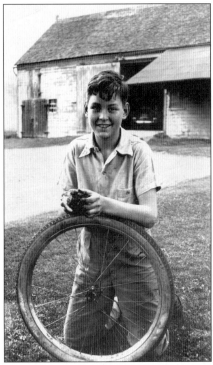

Young Jim Shea (left foreground) and John Irons practice their bicycle repair. Irons (right), obviously pleased with himself and the job he performed on the wheel of his bike, grins broadly. As adults, the two did other sorts of repairs—Shea as a doctor and Irons as a dentist.

Arthur J. Dewey Sr. inspects a new plantation of pines on his property off the Burgess Road in 1929. As a lumberman he regularly inspected his timber stands. Although he owned a car, he had a deep distrust for that form of transportation and never drove. He trusted horses and relied on them to get him where he needed to go.

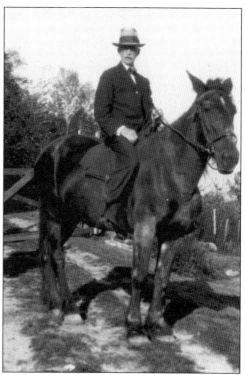

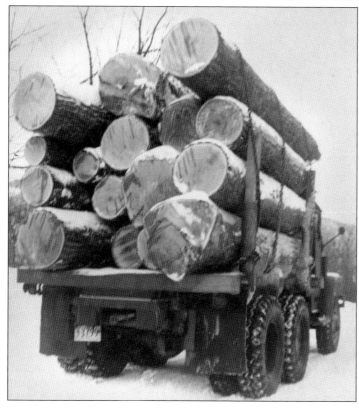

Lumbering was still an active occupation in Woodford in 1959, when this photograph of A.J. Dewey and Sons logging truck was taken.

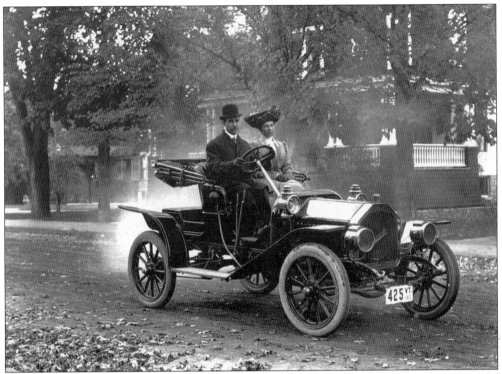

The man behind the wheel of this automobile is Herb Robinson, assistant postmaster. His wife, Nellie Bowers Robinson, sits next to him. They are pictured on Elm Street in front of the Graves house. The house was not built by Mr. and Mrs. Alden Graves but was their home for many years. Charles Burt, the harness maker, lived there before the Graves. George F. Graves lived in the house on the left, which was later replaced by apartments.

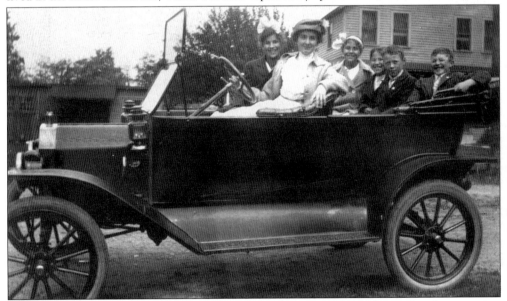

These students are having a great time riding in a 1913 Ford driven by their teacher Eunice Lyons.

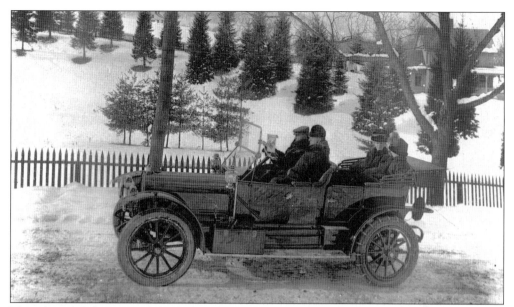

The advent of the automobile changed life in small towns like Bennington. Henry Root sits in his 1910 Rambler on the South Street hill, looking west, just above Weeks Street. The house in the background is on Jefferson Heights opposite Francis Street.

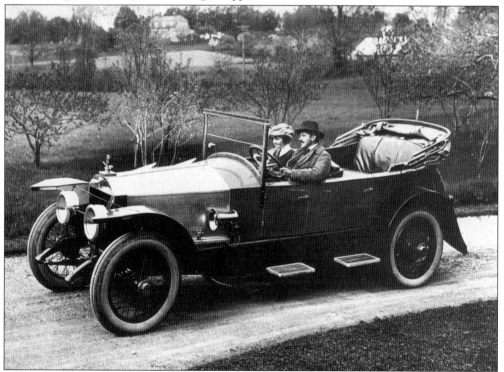

The only automobile ever manufactured in Vermont was made in Bennington by Karl H. Martin. Pictured is Karl Martin giving Mrs. Outhwaite a tour over the back roads in his 1924 wasp. The back of the photograph is inscribed: "Mrs. Outhwaite from the 'Bodybuilder' Karl H. Martin."

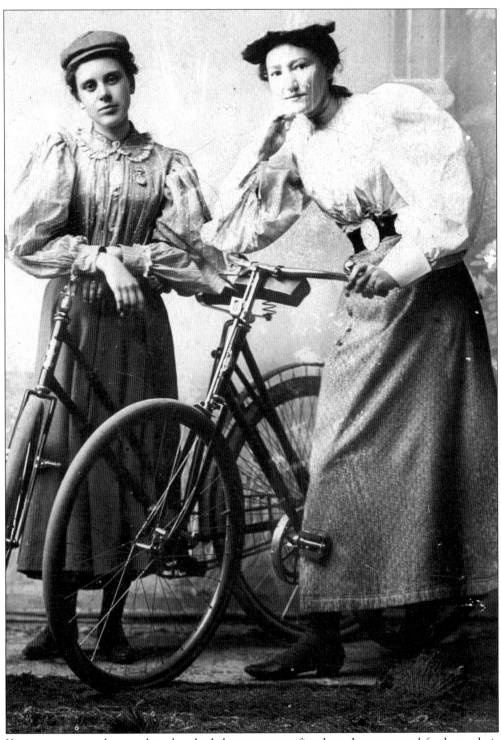

Young women made sure that they had the correct outfit when they ventured forth on their bicycles. Obviously, the proper headgear was part of the total effect. Note the balloon tires on the bicycles.

Five

HOW WE SERVED
OUR COMMUNITY

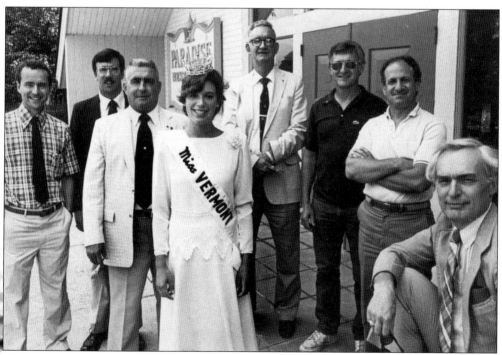

Miss Vermont of 1985, Erica van der Linde, stands at the door to the Paradise Restaurant with, from left to right, Dave Newell, John Pope, Jim Ross, Paul Bohne III, Tony Zazzaro, and Wes Mook—all members of the Rotary Club.

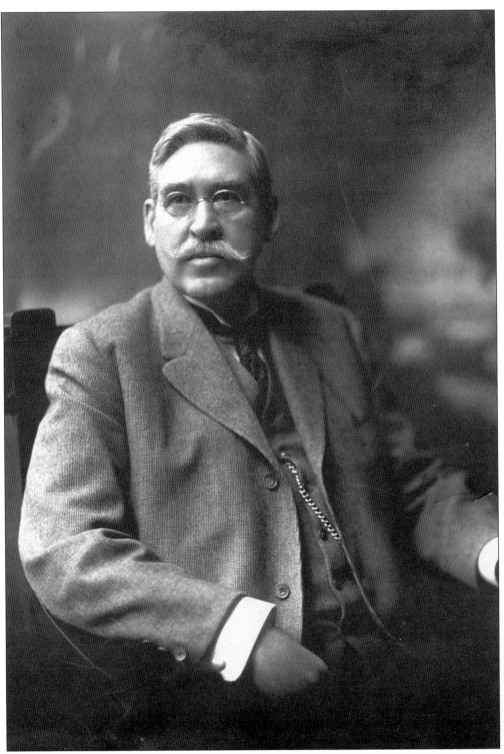
W.H. Bradford, a leading citizen and son of the founder of the Bradford Mill on East Main Street, projects an aura of dignity in this studio photograph.

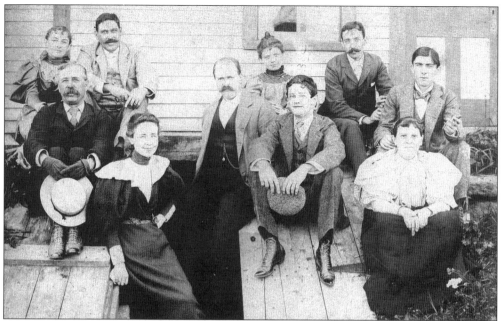

Why this group chose to pose gathered around the bulkhead door, we will never know, but they seem to be happy. The couple in the left rear are W.H. Bradford and his spouse, Daisy Bradford. The youth is Edward W. Dewey, and with him is Cynthia Dewey.

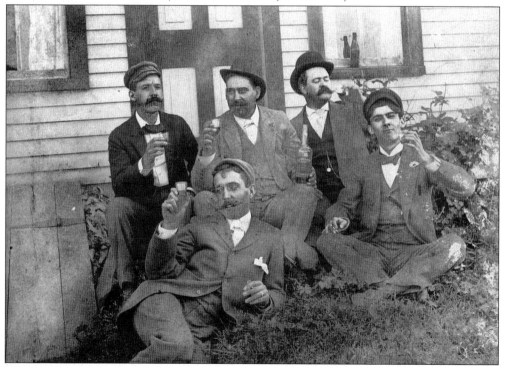

With a sense of accomplishment, William H. Bradford (back center), owner of the Bradford Knitting Mill on East Main Street, and Charles H. Dewey (back right), banker, drink a toast to themselves.

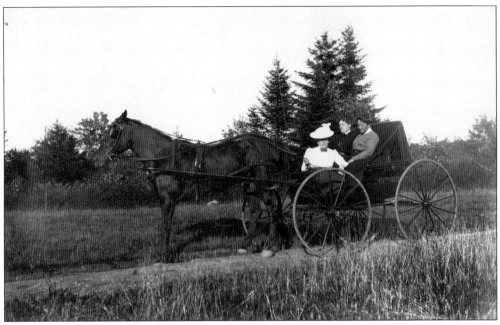

This trio is going for an outing in Woodford to escape from the summer heat. Seated in the buggy are Emma Bradford Dewey, wife of C.H. Dewey; Sarah Frances Dewey Jenney, in the dark dress; and Kathryn Jenney Burrington.

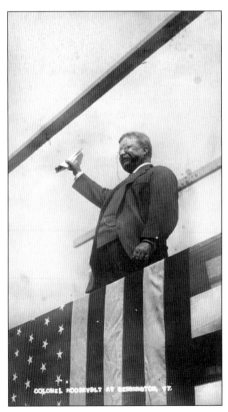

Campaigning in Vermont in 1912 on his own Bull Moose platform, former Pres. Theodore Roosevelt makes a whistle-stop in Bennington.

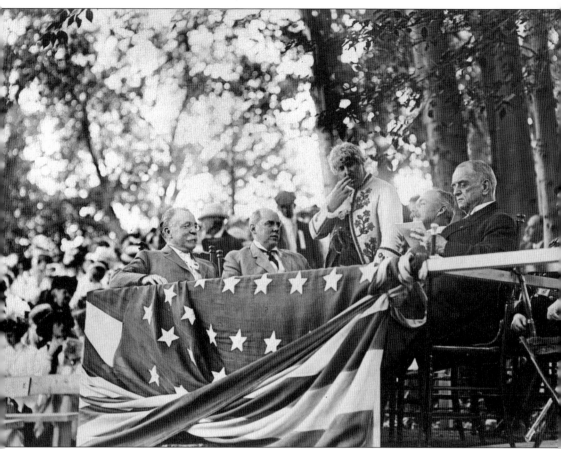

In 1911, Bennington celebrated the 150th year of its settlement. Seated on the speakers platform are Gov. John Mead, U.S. Rep. David Foster, and David Morgan, chief of the Vermont Military Department. The program lists Collins Graves, the elaborately dressed man standing next to the governor, playing the role of Benning Wentworth.

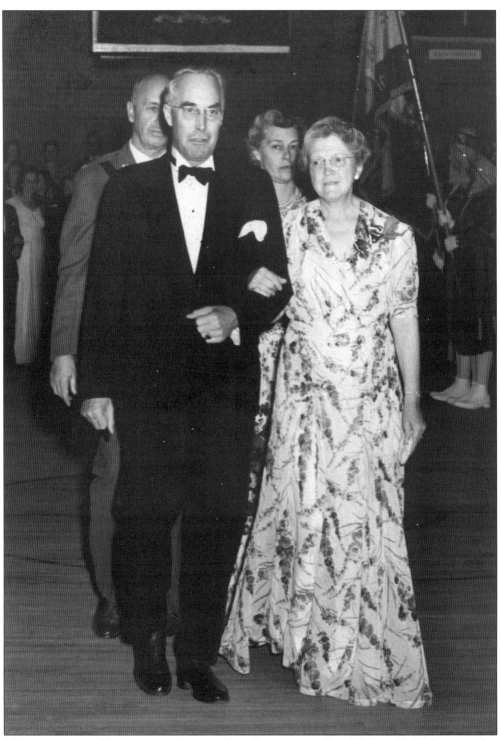

The most recent of five governors to come from Bennington, Gov. William H. Wills escorts his wife, Hazel McLeod Wills, to the Inaugural Ball in 1941. (Courtesy of Stanley Pike.)

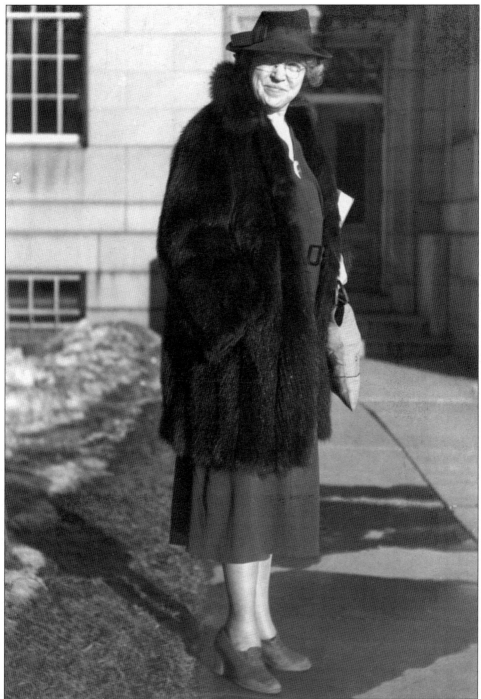

Hazel McCleod Wills, a member of the Committee of Twenty-One, helped shape Bennington College as proposed by Dr. Ravi Booth. Not only was she a signer of the Articles of Association in 1925, she also became a trustee in 1946, a position she held for 14 years. She was Vermont's first lady from 1941 to 1945 and then, in her sixties, was elected to the State Senate. When she died in 1969, the state of Vermont lost a valued person. (Courtesy of Stanley Pike.)

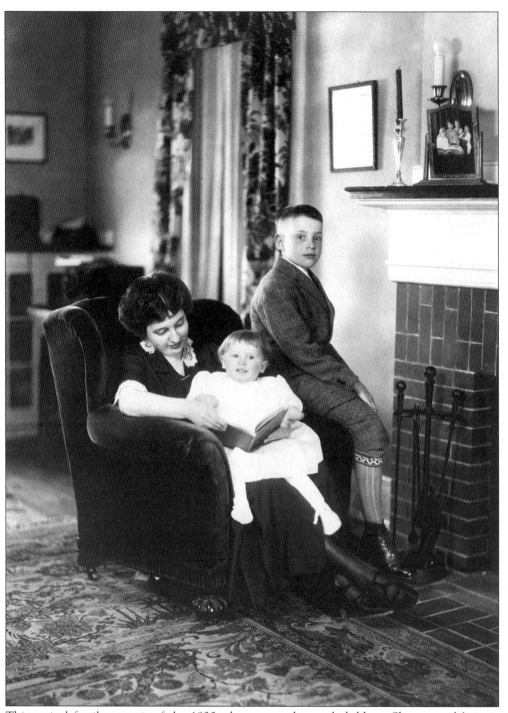

This typical family portrait of the 1920s shows a mother and children. Shown are Marjorie Shurtleff Root, wife of Henry G. Root, with two of her children, Mary Root Mollica and William Root. William Root was killed in action in the European theater during World War II.

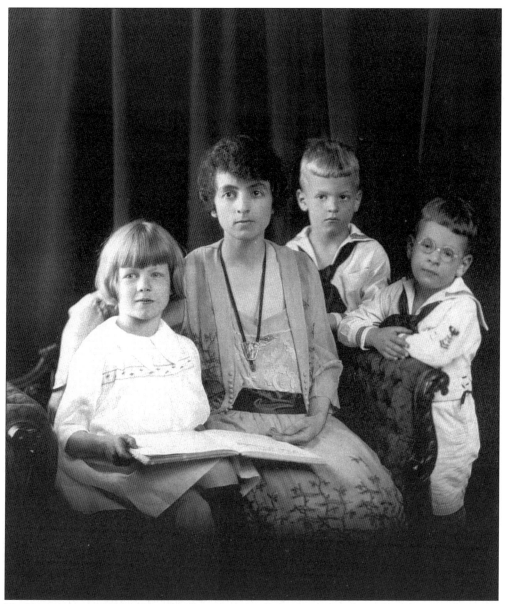

Visible on the mantle in the previous portrait of the Root family is this photograph of the Dewey family. Janet Drysdale Shurtleff Dewey (second from left) was the wife of Edward W. Dewey and the sister of Marjorie Shurtleff Root. She is pictured with her three children, Jean Drysdale Dewey, Robert Bradford Dewey, and Charles Henry Dewey.

1st Lt. William Root II was killed in action in Germany on April 4, 1945. He earned the Bronze Star, the Silver Star, and the Purple Heart. The Root ancestral home is the present Bennington Town Hall. (Courtesy of Mary Mollica.)

Walter H. Berry stands at the door of his historic inn. The Walloomsac Inn, located on the corner of Monument Avenue and Route 9 in Old Bennington, was built prior to the Revolutionary War. Known then as the Dewey Inn, it had the distinction of providing hospitality for James Madison, James Monroe, and Thomas Jefferson.

James S. Holden, chief justice of the Vermont Supreme Court, also served as national commander of the 43rd Infantry Division Veterans Association, rising to the rank of major during army service in World War II in the Pacific theater. (Courtesy of Helen Holden.)

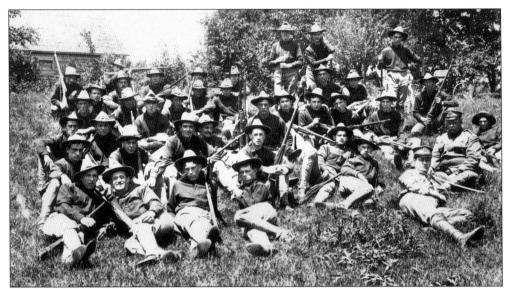

Taking their ease in the countryside on February 1, 1922, are members of the Howitzer Company of the 172nd Infantry. The men are identified as L.H. Boyd, Halsey Cushman, William Tancred, Fillmore R. Paddock, G. Spencer Lee, William Wishart, Clarence Brown, Joseph Lauzon, Raymond Barlow, Leslie Fleming, Hector Betit, Fred Stone, Ernest P. Leonard, Clyde W. Peck, John H. Burhyte, Alphege Cardinal, Anthony Vallee, John B. Elwell, ? Ayers, Frederick Ranzona, Wiley Sexton, Charles Sleeman, Russell O'Connell, Raymond Higgins, Edward Warner, Frederick Carey, Franklyn Hyde, Arthur Butler, Kenneth Jolivette, Martin Cutler, Leo Plante, George Morin, Oscar Tellier, Leon J. Greenwood (bugler), Wilfred Langlois, Harold Ryder, Charles Murphy, Harold Brewer, Oscar Oslund, Robert F. Halstrom, Gerald J. Morin, Theodore Galipeau, Arthur Rousseau, Edward Joseph, Frank Kelley, Earl Thompson, Joseph Costello, Raymond Bleau, Darrell Sawyer, Arnold Knapp, Robert Hogan, Buell Weeks, Norbert Goady, Carl Brown James Gibney, George Bugbee, and Jon Toomey.

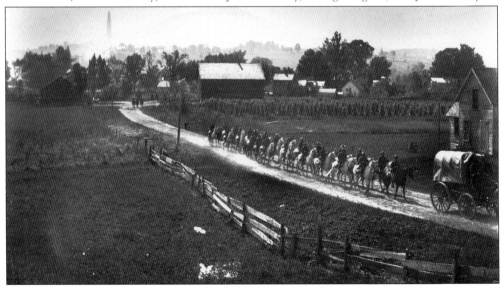

World War I cavalry troops ride up Harwood Hill. The supply wagon is in the foreground, and the Bennington Battle Monument is silhouetted against Mount Anthony in the background.

80

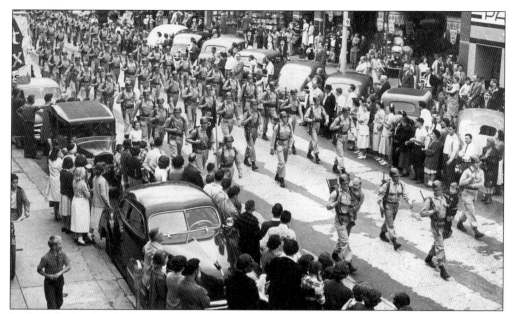

In the fall of 1950, Company I, Vermont National Guard, marches down Main Street to board a train at Bennington Station to take part in the Korean War. Leading the troops is Cmdr. Joseph Krawczyk, whose son Joey Krawczyk ran from the sidelines and was carried the rest of the way in his father's arms. (Courtesy of Gordon Lyons.)

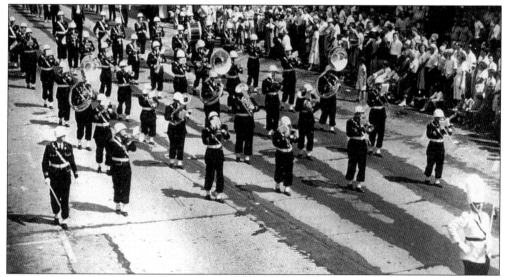

The Vermont State American Legion convention was held in Bennington in July 1949. Led by Bennington Post 13, the American Legion Band marches down Main Street. Len Morse (not pictured) directs the band and Lynn Wood Jr. is the drum major. Other members include trumpeters Leo Diussa, Jerry Butler, Roger Marcoux, Stuart Dumas, Gerry Gladue, Ed Keough, Earl Hamilton, and Bob McKeon; trombonists Maurice Winn, Fred LaCroix, Peanut Rice, Bill Knights, and John Howard; baritone players Ray Philputt, Art Murphy, Walt Dunham, and Arnold Hohman; sousaphonists Ding Daigneault, Ted Kennedy, and Quincy Harrington; clarinetists Russell Carpenter, Doug Brunina, Nick Marra, Clarkson Eaton, and Walter Lehman; drummers Ernie Caron, Ronald Knapp, and Bill Hart; and cymbalist Leo Belanger.

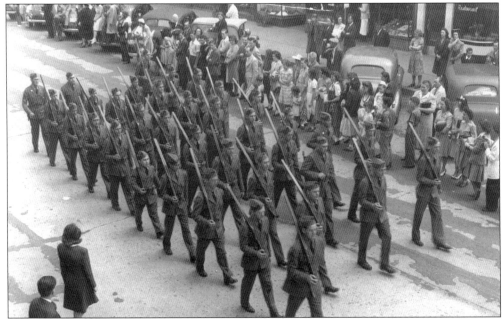

Company B of the Vermont Home Guard marches down Main Street in the Memorial Day parade on May 30, 1943. It is difficult to find any young men among the spectators since most were serving elsewhere.

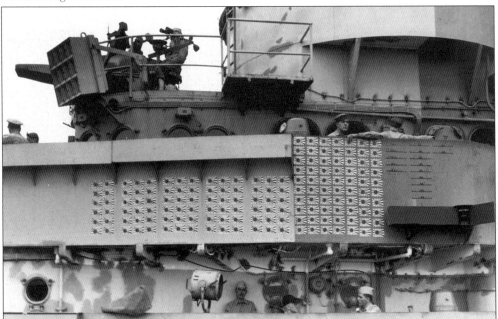

The aircraft carrier USS *Bennington* proudly displays its number of "kills." The flags to the left indicate the number of planes downed, and the outlines on the right show the number of ships disabled or sunk. All Essex-class carriers built in World War II are named after Revolutionary War battles. The *Bennington,* named to honor the battle, served with great honor from World War II through Vietnam. The ship was decommissioned in 1973. Its bell hangs outside town hall. (Courtesy of the Bennington Museum.)

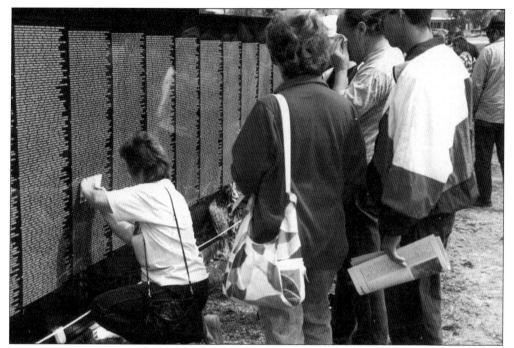

Displayed at the Vermont Veterans Home, the Moving Wall brings members of the Bennington community together to pay tribute to those soldiers who participated in the Vietnam conflict. (Courtesy of John J. Miner.)

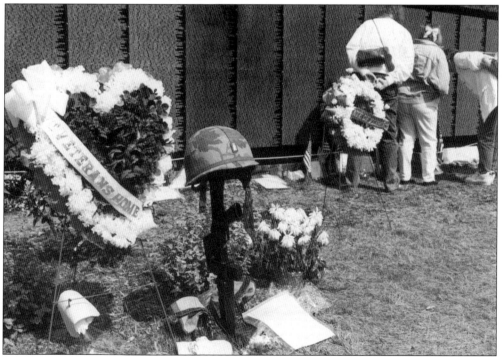

Brig. Gen. Robert Maskiell of Shaftsbury displays his helmet and rifle as a tribute to his former comrades in front of the Vietnam Moving Wall. (Courtesy of John J. Miner.)

Carleton Carpenter, a native son whose acting and musical talent took him to Broadway, relaxes between roles. He debuted in *Bright Boy* in 1944, made the film *Two Weeks with Love* with Debbie Reynolds, and was featured as a guest performer at Bennington's Oldcastle Theatre Company during the 2000–2001 season.

Six
HOW WE HAD FUN

Young Mamie Shurtleff performs with fellow thespians in a rendition of Charles Dickens's
David Copperfield.

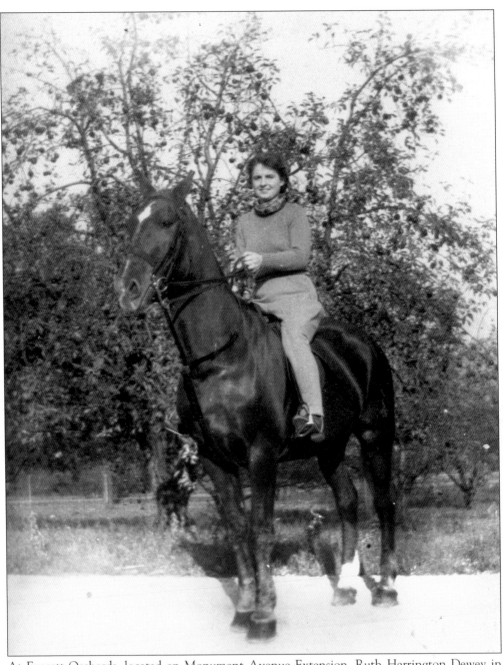

At Everett Orchards, located on Monument Avenue Extension, Ruth Harrington Dewey in 1938 enjoys a ride on the horse of George Stobie, the groom of Edward Everett.

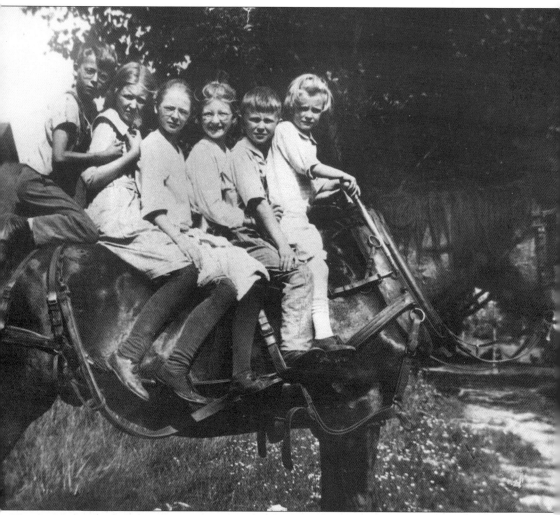

The draft horse Tuck patiently carries, from left to right, Lester Harwood, Diantha Lyman Hall, Harriet Harwood Vickland, Helen Lyman, Joseph Lyman III, and Mary Lyman Haviland at the Harwood Farm on Harwood Hill in Bennington in 1915. (Photograph by Marion Harwood.)

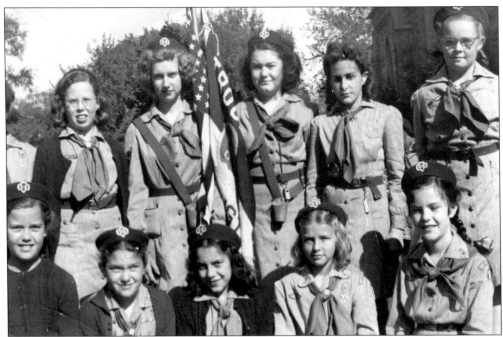

These girls from various local troops attended St. Francis de Sales Church on Girl Scout Sunday in 1943 or 1944. From left to right are the following: (front row) Veneta Horst, unidentified, Tedi Petrelis, J. Peckham, and Virginia Horst; (back row) ? Austin, Joan Reed, Gail Ryan, Ina Buck, and Elizabeth Browning.

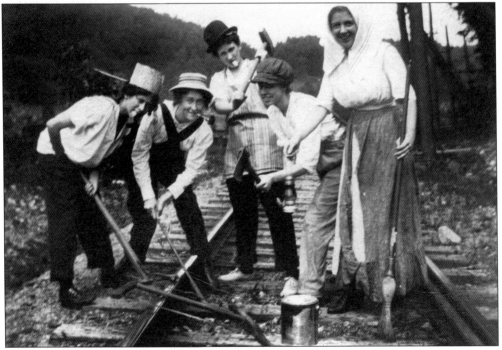

"Working on the trolley line" near Camp Cozy in Pownal in 1910 are Kathryn Burt Young (second from left), Barbara Burt (center), and Bertha Lambert Burt (far right).

In August 1943, Polly Ridlon Wilson prepares food at the original Glastenbury Camp on the Long Trail of Vermont near the fire tower on the summit of Glastenbury Mountain.

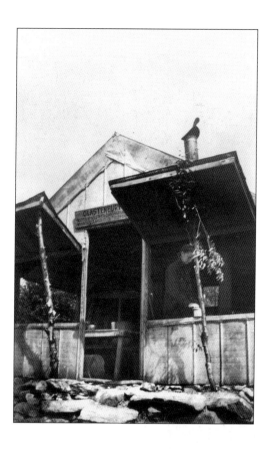

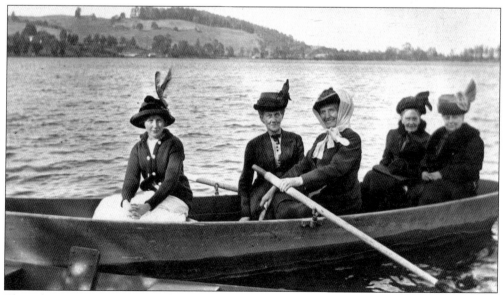

These five women spend some time on the lake. They include Mrs. Homer Lyons, Mrs. William Hawks, and Mrs. Blanchard.

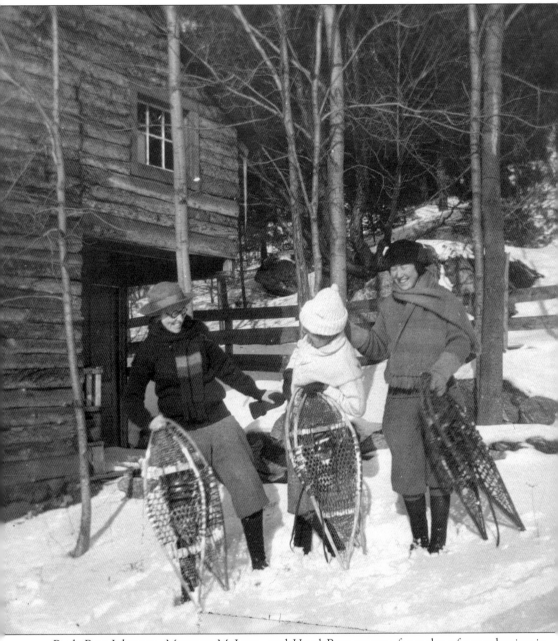

Ruth Burt Johnston, Margaret McLean, and Hazel Burt prepare for a day of snowshoeing in Woodford. Outdoor clothing has changed drastically since 1914, when this picture was taken.

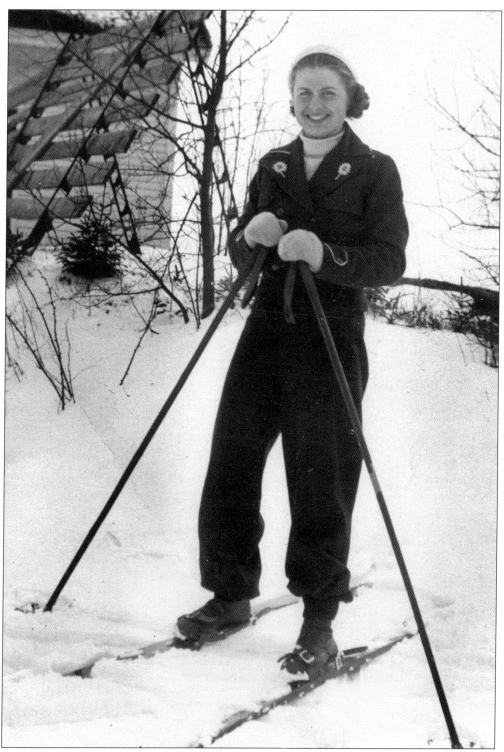

Known for its snowfall, Woodford is the ideal place for residents of Bennington, such as Ruth Harrington Dewey, to enjoy downhill skiing.

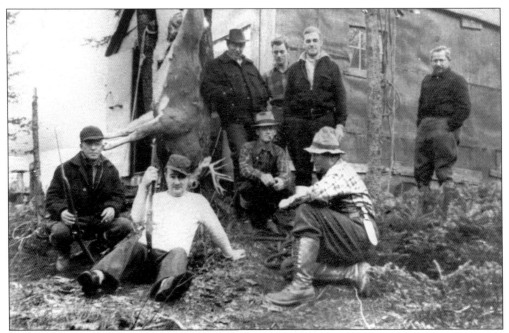

Hunting and deer camps have long been a Vermont tradition. At Pine Valley Deer Camp in 1940, these Benningtonians show off a good size buck. They include C. Bellis, C. Worden (cook), C. Peck (sheriff), J. Woodward (contractor), E. Silver (fire and police chief), B. Dewey, and E. Delaney (Hoosick hotel owner).

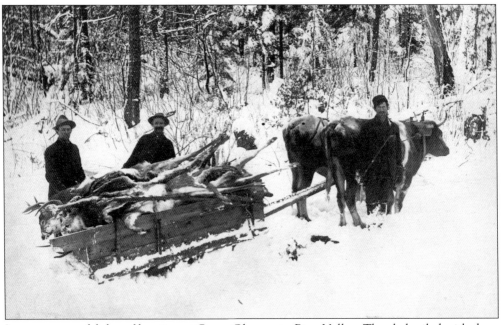

It was a successful day of hunting at Camp Gleason in Pine Valley. The sled, piled with deer, is pulled by two sturdy oxen. (Courtesy of Robert Purdy.)

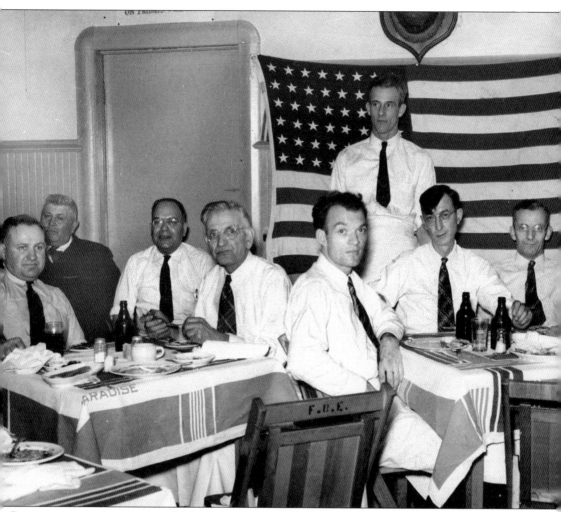

Game suppers were important fund-raising events in Bennington. Diners could sample exotic fare such as groundhog, bear, squirrel, pheasant, and perhaps quail. This supper took place in 1943 at the Fraternal Order of Eagles. Shown are D. Delude, N. Perrott, E. Petrelis, N. Petras, H. Goewey, ? Dufresne, L. Goewey, and N. Bridge. (Courtesy of Beverley Petrelis.)

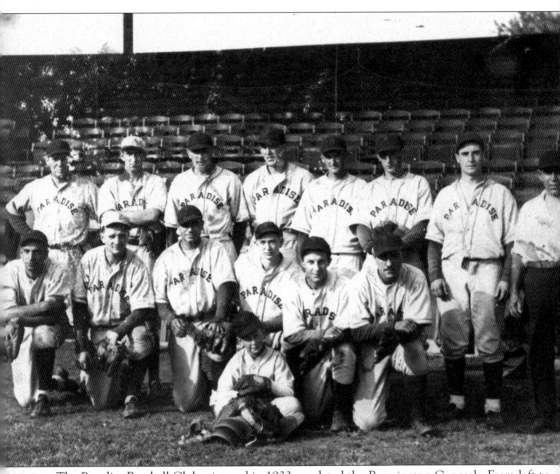

The Paradise Baseball Club, pictured in 1933, predated the Bennington Generals. From left to right are the following: (front row) Shanahan (mascot); (middle row) Tinker, Bokina, J. Pello, Schiemenz, Devito, and D. Pello; (back row) Williams, Colville, Austin, Rickert, Butler, Perrott, Carrigan, and Playotes (manager).

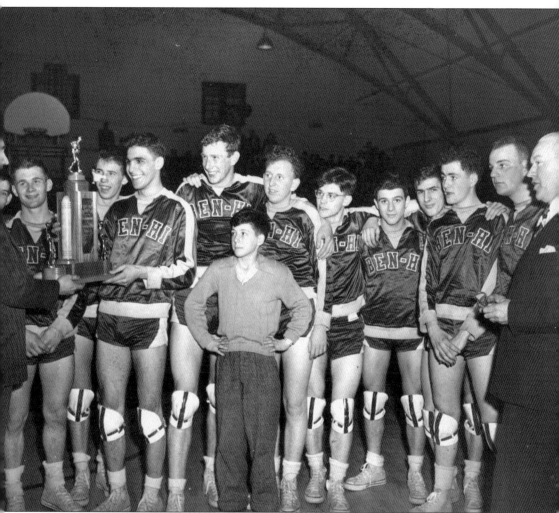

Gov. Ernest Gibson (left) presents the trophy to the Southern Vermont Basketball Champions of 1948. Team members are John McNeilly, Skip Hogan, Butch Corbett, Charles Salem, Dan Scott, Tom Meaney, Dick Garant, Carlton Labarge, Gerry LaCroix, Bob Evans, and Bob Gratton. Thomas Siciliano (center) is team manager. Harold O'Brien (right) represents the Rutland Rotary Club, cosponsor of the tournament.

Theater has always been an important aspect of life in Bennington. In 1933, *The Closed Door* featured Viola Jolivette as Louise Grey, Ralph Norton as Izzy Cohen, and Helen Cushman as Celia May. (Courtesy of the Bennington Museum.)

Also appearing in *The Closed Door* was Priscilla B. Norton, wife of Ralph Norton, as Marion Mudge. Note the automobile behind her. (Courtesy of the Bennington Museum.)

Miss Burdick came from Hoosick Falls by trolley each week to teach dancing. Classes were held above the Bennington Banner office. The Banner paperboys often teased the dance students. Ready for a recital, from left to right, are the following: (front row) John McCullough Turner, Miriam Shakshober, and Frances Holden; (middle row) Molly Drysdale, Van Vechten Graves, Carolyn Jones, Tirzah Ayers, Richard Holden, and Mary Shakshober; (back row) Miss Burdick, Elizabeth Rockwood, Charles Moore, Waldo Holden, George Graves, and Charles Bennett.

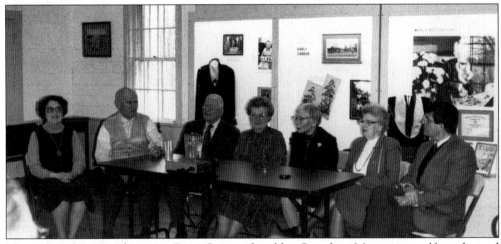

This group discusses the artist Patsy Santo who, like Grandma Moses, was self-taught and painted local scenes. The Bennington Museum often hosts such programs, and this one, held in the Grandma Moses Schoolhouse gallery, is particularly fitting. From left to right are Carol Santo Johnston, granddaughter of the artist; John Griffin; Carl Santo, son of the artist; Florence Bridge Santo, wife of Carl Santo; Ruth Levin, moderator and museum registrar; Violetta Santo, daughter of the artist; and Nicholas Santo, grandson of the artist. (Courtesy of the Bennington Museum.)

Seven

HOW OUR STREETS
HAVE CHANGED

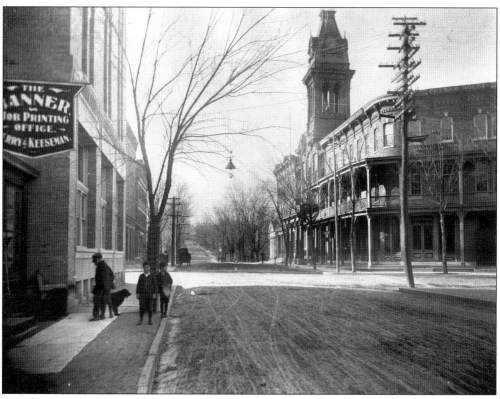

Newsboys wait in front of the Bennington Banner building, at the corner of North and Main Streets. The Putnam Hotel and the courthouse, diagonally across the street, look deserted. Even South Street is empty of traffic.

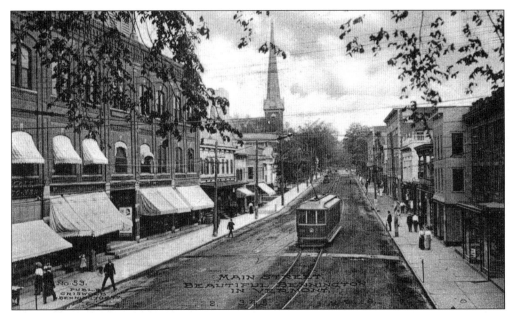

Trolley tracks and a trolley car dominate East Main Street sometime after 1907. On the left are the Opera House, the Methodist Episcopal church, the YMCA building, the Second Congregational Church (with steeple), and the Masonic Temple. On the right is the post office. Griswold's store and the Baptist church can also be identified.

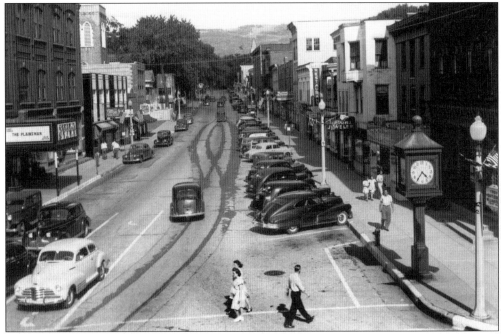

East Main Street has changed. The Opera House auditorium is now the General Stark Movie Theater, with the Bennington Club (no longer men only) above it. The trolley tracks are gone, along with the Second Congregational Church steeple. The post office is now the Chittenden Bank. Note the two parking patterns: diagonal on the south side and parallel on the north side. (Photographer: Robert L. Weichert. Courtesy of Images of the Past/Bennington, Vt.)

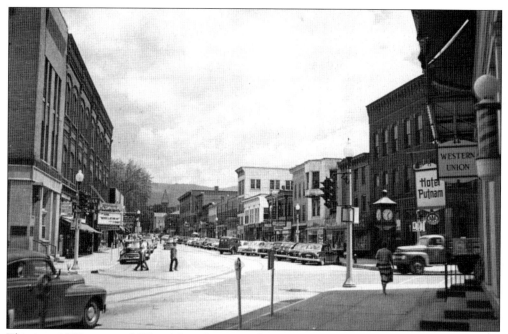

This is a 1950s view of West Main Street at the Four Corners. The Hotel Putnam catered to travelers, and the new parking meters helped toward the costs of accommodating increased motor traffic.

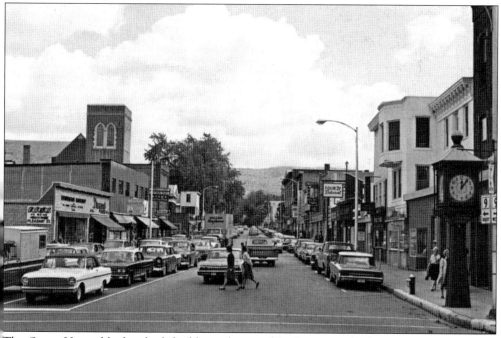

The Opera House block, which had been destroyed by fire, was rebuilt to accommodate small stores and a restaurant.

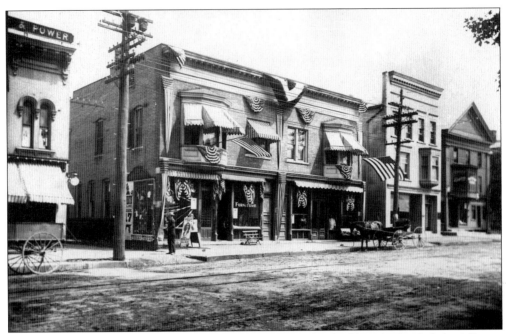

Located on Main Street east of the Masonic Temple, this building looks slightly different than it did in 1910. For many years known as Geannelis' Restaurant, Lulu's now carries on the tradition.

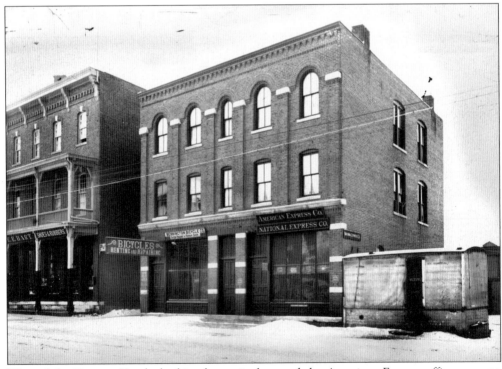

West of the Putnam Hotel, the bicycle repair shop and the American Express office were on the street level in this building. The Gift Garden flower shop is located here.

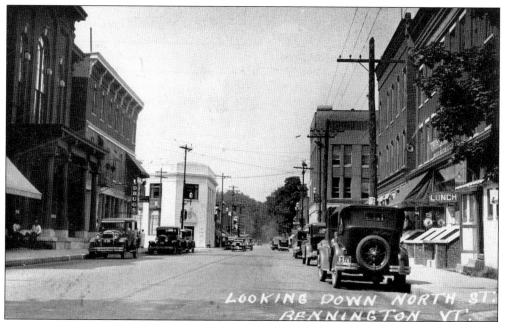

Except for the vintage automobiles and the lunch counter and diner on the right side of the street, this photograph shows that little has changed at the Four Corners (Putnam Square).

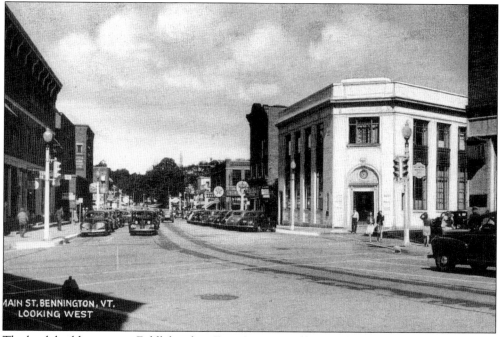

The bank building is now Fiddleheads at Four Corners Gallery, and the Texaco station has been moved to the back lot. The Bennington Battle Monument can be seen in the distance.

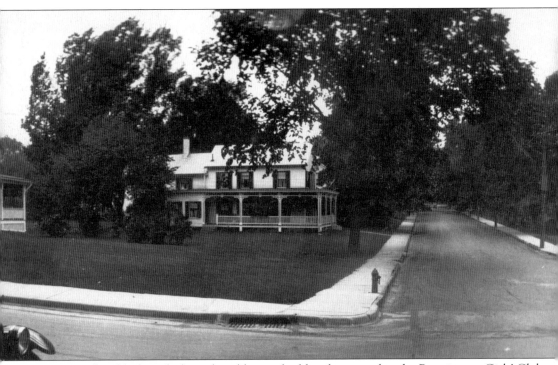

Originally a blacksmith shop, this old stone building has served as the Bennington Girls' Club, civil defense headquarters during World War II, a gift shop and interior design studio, and the police station. Note the traffic marker telling drivers to keep to the right. The Texaco station

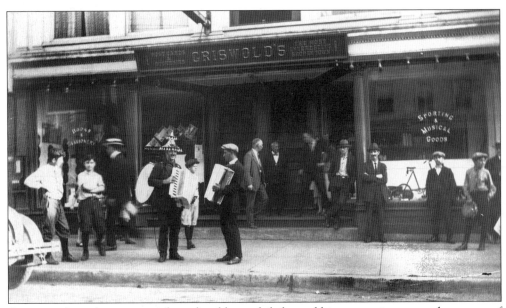

One accordion player sports a fancy headdress while he and his companion serenade a group of men in front of Griswold's store, on Main Street. According to the sign over the door, this is the "Most Interesting Store in Bennington."

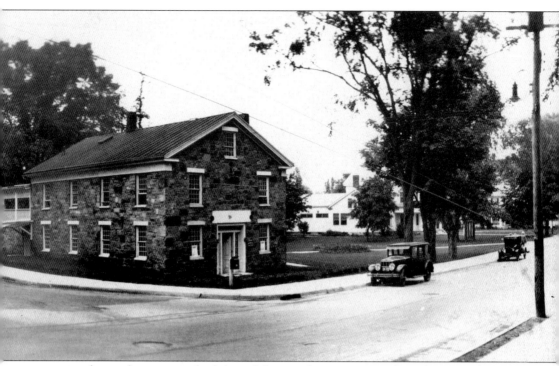

now occupies the south corner to the left, and the courthouse now stands in the empty lot to the right of the stone building.

Albert Bolles of Woodford and Marshall Hapgood carry on a lively discussion across Main Street from the Opera House and Charles Cole Outfitters, a men's clothing store.

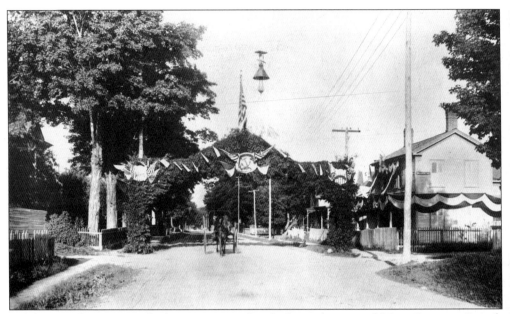

Celebrating the centennial of Vermont statehood, this arch spanned Main Street at Branch Street, not far from Salem's store.

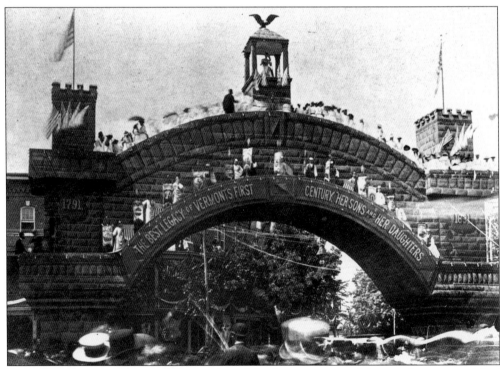

Erected at the intersection of Routes 9 and 7, this structure celebrates the centennial of Vermont statehood. It is inscribed "The Best Legacy of Vermont's First Century: Her Sons and Her Daughters." Those very sons and daughters stand on the arch.

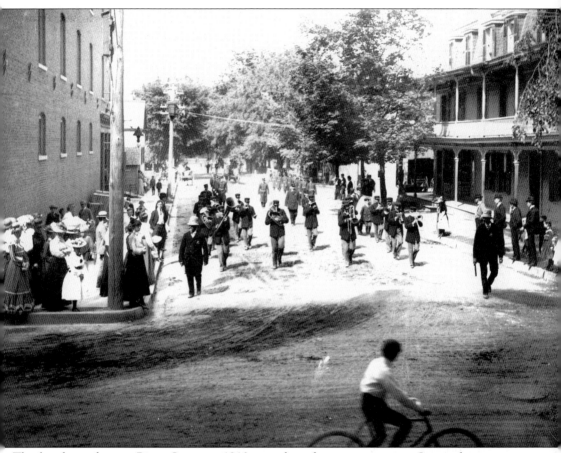

The band marches up River Street *c.* 1910 on a long-forgotten occasion. It was, however, important enough for the women to turn out in their finery. The Dewey House Hotel is on the right, and one of the first of Drysdale's stores is on the left.

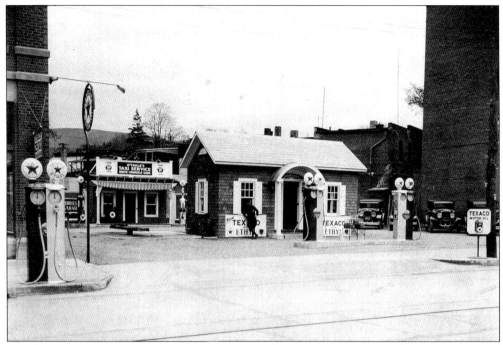

On a slow day at the Texaco station on the north side of Main Street, the attendant leans against the building and relaxes. Located between what is today the Left Bank Gallery and the Community College of Vermont, O'Toole's also provided both a taxi and a "drive-yourself" car service. (Courtesy of Ellis Winslow.)

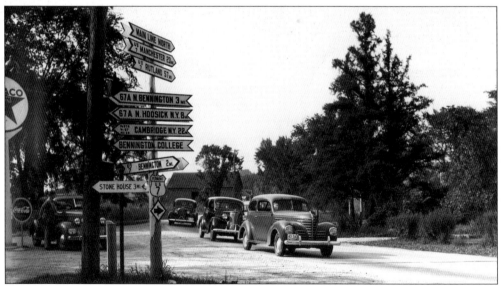

The signpost at the intersection of Routes 7 and 67A provides motorists with all the information they need. Haynes and Kane's furniture store replaced the Texaco station. The signpost, more discreet today, is not nearly as informative. (Photographer: Robert L. Weichert. Courtesy of Images of the Past/Bennington, Vt.)

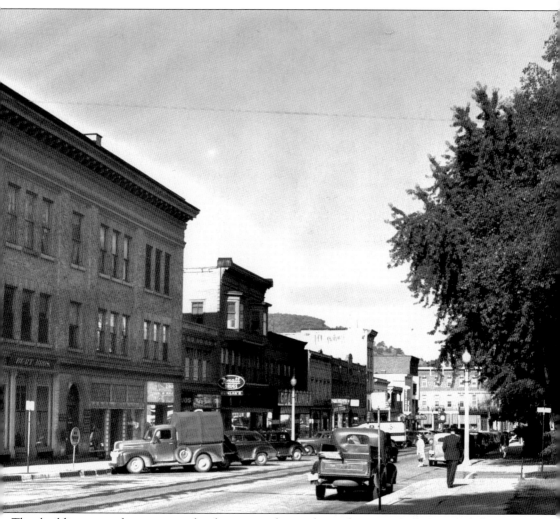

The buildings are the same—only the names have changed since 1946. Burt Brothers, Quinlan's Drug Store, Twin State Gas and Electric Company, and the Grand Union have been replaced by the Bennington Bookshop, the Army and Navy Store, and Star Electric.

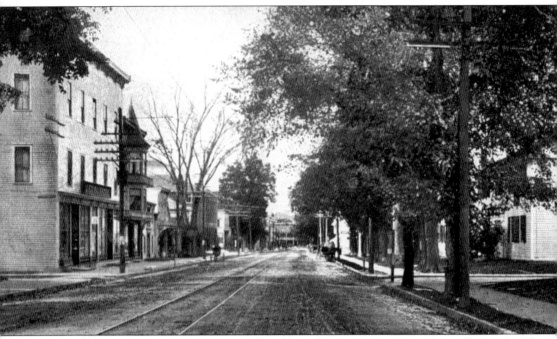

The trees are gone from the corner of Valentine and Main Streets, as are the trolley tracks. The corner of the porch glimpsed at the right is now the Mexican Connection, while the Putnam Hotel is still visible in the distance.

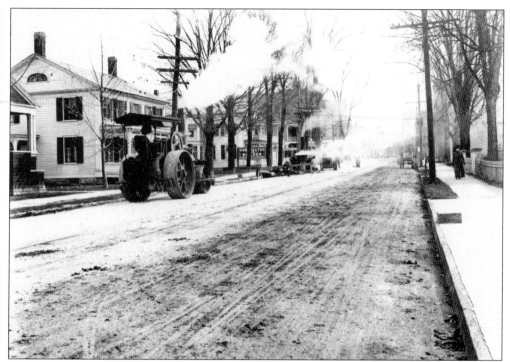

In 1920, the steamroller paves Main Street east of Depot Street and Washington Avenue. The trolley tracks run down the middle of the street, and telephone poles line the sidewalk.

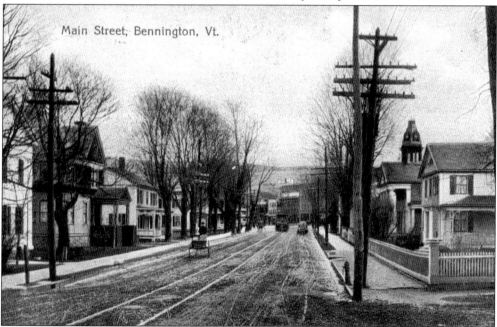

In this view of Main Street, looking east toward Woodford, a man appears to be pushing a vendor's cart. The message on the back of this postcard invites friends from White Creek, New York, to come and stay overnight in Bennington, and assures them they will be met in North Bennington, which means they would be coming on the trolley or shuttle train.

Many of the houses built in Bennington during the 19th century were of similar style. Located at the corner of Gage and North Branch Streets, this house reflects the prevalent architecture of the day.

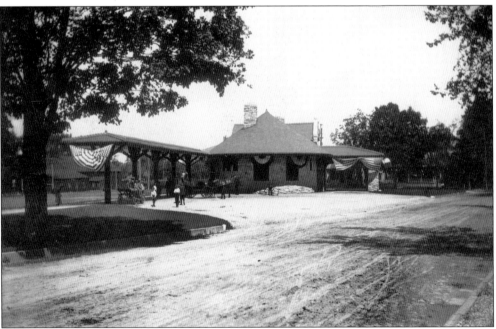

The Bennington Railroad Station, built in 1898, utilized blue marble shaped to look like granite. No longer a train station, the building served as a Vermont State Liquor Store for a time and, today, is the Bennington Station restaurant.

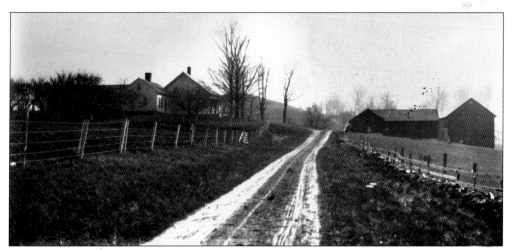

This road today is wider and paved, but the view heading south on the South Stream Road remains constant. A traveler can still catch a glimpse of horses grazing.

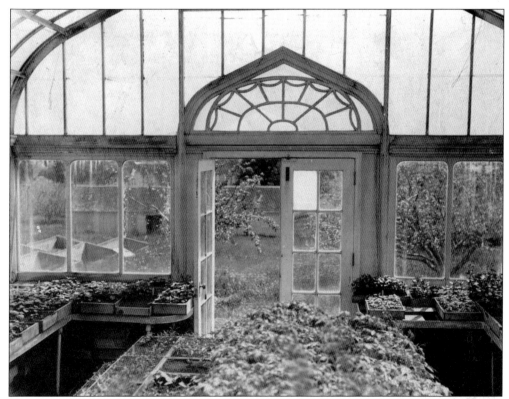

This greenhouse at the Edward Everett Estate was immediately adjacent to the gardener's cottage located just to the south of present-day Corey Lane. The property was eventually sold, the cottage was converted to a private residence, and the greenhouse was razed.

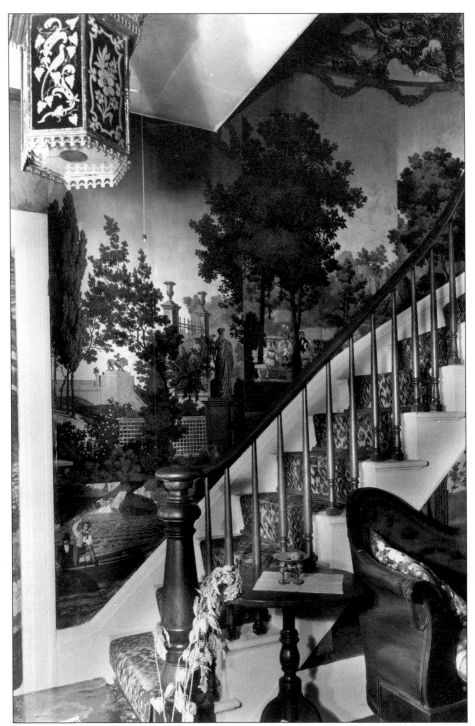

The front staircase in the Dewey Homestead on West Main Street is shown with hand-blocked French wallpaper made *c*. 1830. The Sandwich glass light now hangs in the Church Gallery in the Bennington Museum. Across the street, Alcaro Motor and Sales Inc. is located in what was once the Dewey barn.

Eight

HOW WE WERE

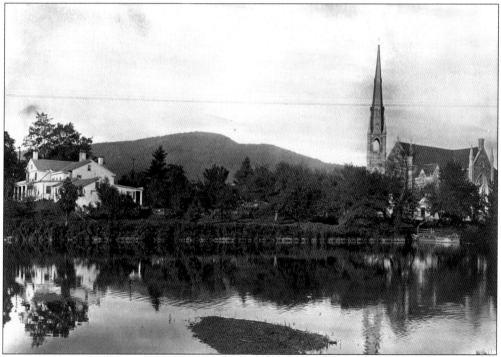

The Dewey Homestead, built in 1769 and 1774, was demolished in 1956 in order to build a parking lot. Local tradition says that it was here that the women of the town gathered before the Battle of Bennington. The water from Depot pond went through a pipe, five feet in diameter, to the Holden Leonard mill on Benmont Avenue. The spire on St. Francis de Sales Church, seen on the horizon, blew off in 1927.

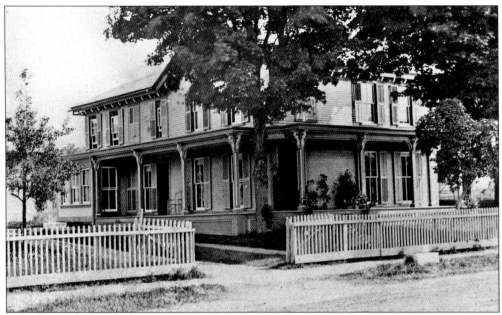

The Rockwood House on East Main Street stood opposite the Rockwood Mill. Built by Samuel Rockwood and owned by George Rockwood and then Arthur Rockwood, the building accidentally burned down. The property is currently owned by the Fraternal Order of Moose.

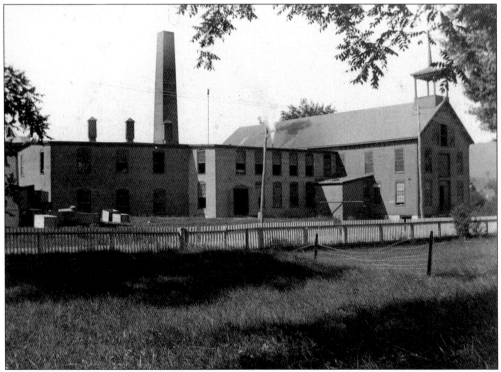

Founded by Samuel Rockwood and owned by his son George Rockwood and George's son Arthur, the Rockwood Mill was built in 1850. The remains of the foundation can still be seen today at the corner of East Main and Rockwood Street.

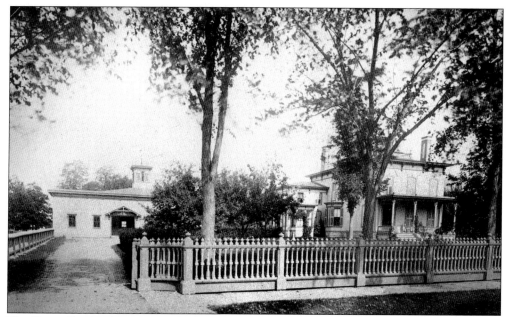

The Henry Bradford House was built in 1865 on East Main Street. Henry Bradford, like most of the mill owners, built his impressive house across the street from his mill. The house is pictured before it had a wraparound porch.

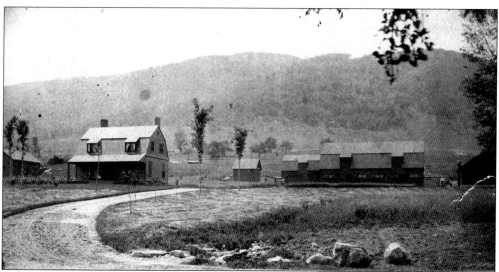

When Edward Everett purchased various properties and established the Everett Orchards, the Griswold Farmhouse, built in 1884, became the office with an apartment upstairs. The porch was removed. The large barns stabled horses and various equipment. Located on Monument Avenue Extension, the farmhouse was destroyed by fire in 1984. The barns burned later. Both fires were thought to be arson.

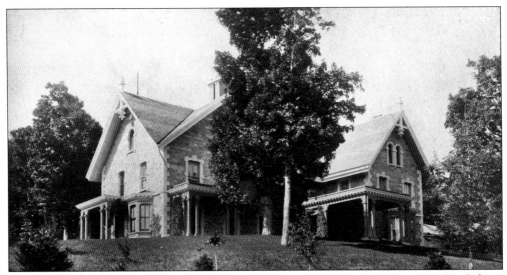

The D.H. Conklin Estate was located on Mount Anthony at the same site as the Colgate Mansion. Built in 1865 by D.H. Conklin, it passed to the Tibbits family of Troy and Hoosick, New York, and finally to J.C. Colgate. It was destroyed by fire in 1899.

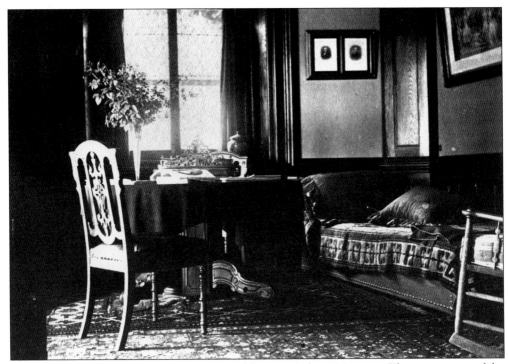

This view shows the interior of the D.H. Conklin-J.C. Colgate Mansion. The appearance of the room reflects a casual summer atmosphere.

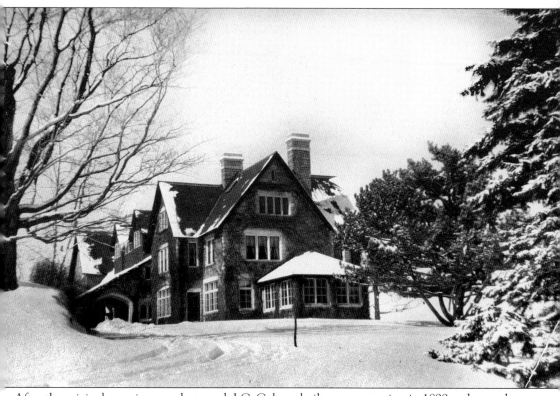

After the original mansion was destroyed, J.C. Colgate built a new mansion in 1899 and named it Ben Venue. It was torn down in 1956, and the stones were used to erect a new wing of the Bennington Museum.

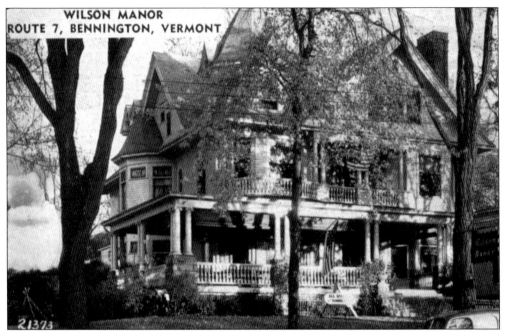

Built as a private home, this house eventually became a guesthouse called Wilson Manor. Located on the corner of South Street and Hillside Street, it was later replaced by Friendly's restaurant.

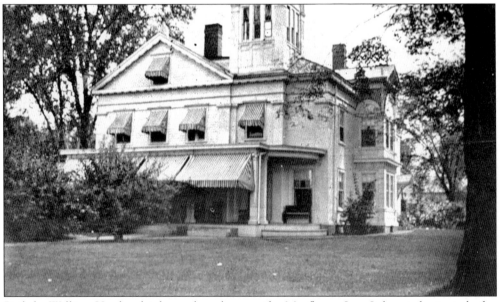

Built by William Hawks, this house later became the Mayflower Inn. It boasted private baths, meals, homegrown vegetables, and parking space for cars and trailers. Located at 215 North Street, the building was razed to build the Grand Union supermarket. It now houses the Vermont State Motor Vehicle Department, a floor-covering store, and a bank.

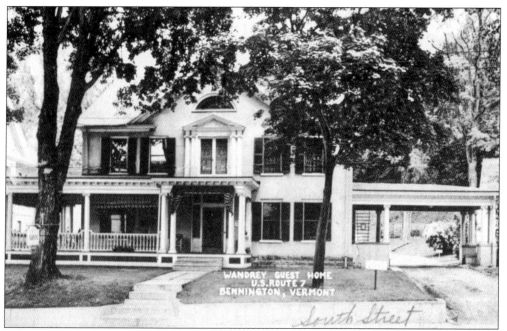

All that remains of the Wandrey Guest Home on South Street is the garage that housed the offices of Dr. Shea and, later, of the sheriff's department. The house (next to Friendly's) was razed for a parking lot.

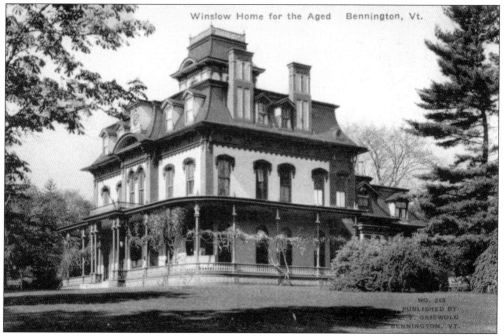

Built during the Civil War by the pioneer banker Luther Graves and occupied by him until his death, this Washington Avenue house in 1923 became the Winslow Home for the Aged. Later, it was purchased by the Elks Club, which demolished it and constructed a new building. The carriage house still remains at the back of the lot.

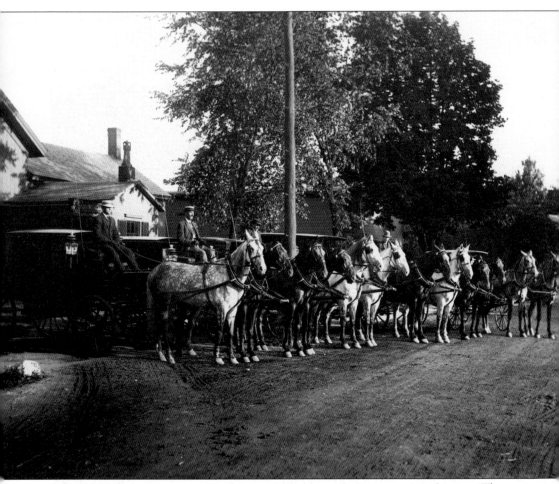

Waiting for fares, carriages at Tuttle's Livery Stables make an impressive showing. The carriage on the left is now in the Shelburne Museum. Because of the shortage of gas during World War II, these carriages were used by some residents for transportation around town.

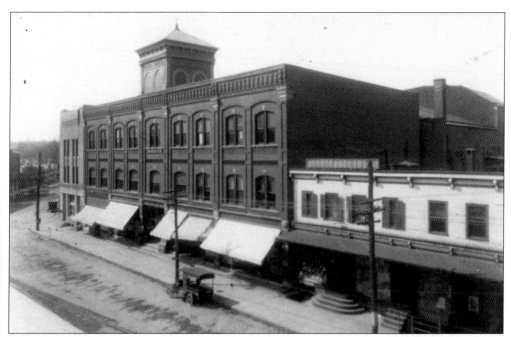

The Opera House on Main Street, built by Henry Putnam, burned in 1959. The two-story wooden building on the right is now the location of the Madison Brewery restaurant.

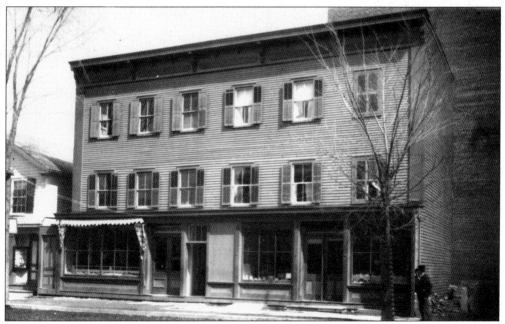

The Bennington Banner was located in this building at the corner of North and Main Streets. The building is long gone, and in its place is now a small park where Under the Tent activities are held in the summer.

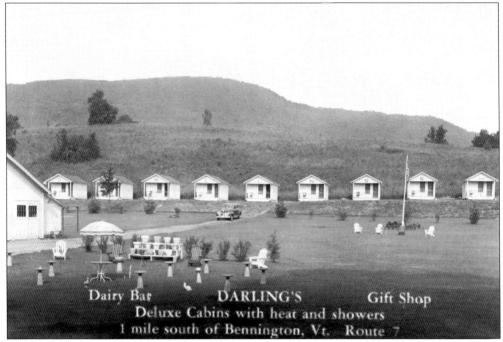

Dairy Bar DARLING'S Gift Shop
Deluxe Cabins with heat and showers
1 mile south of Bennington, Vt. Route 7

The popularity of the automobile gave birth in the early 1930s to tourist cabins. This postcard shows an excellent example of such. The cabins were connected to form a motel, which is now called Darling Kelley's.

The Yellow Barn was a community club used for social and cultural events. Located on the corner of Bank Street and Monument Avenue in Old Bennington, it was, unfortunately, demolished before World War II.

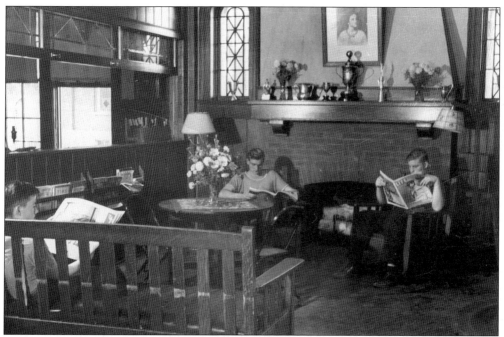

Members of the Young Men's Christian Association (YMCA) enjoy a quiet moment in 1940.

Leonard "Blackie" Black (front row, second from the left) was the YMCA director and a mentor to many young people in Bennington. This social function was held on the second floor of the Y in 1940. The Y closed in 1972 after an unsuccessful campaign to build a town swimming pool.

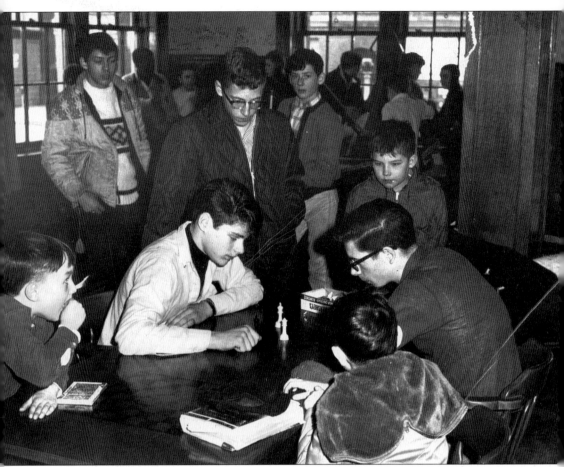

The concentration of the two chess players is reflected in the faces of the boys crowded into the lobby of the YMCA.

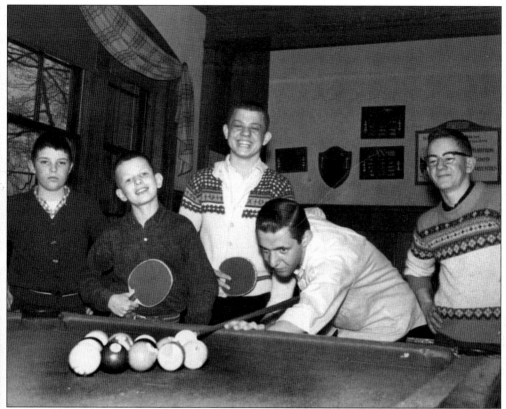

Pool and table tennis players are cheered on by fellow YMCA members, from left to right, Howard Therrien, Larry Guetti, Chip Durocher, Ed Ballance, and unidentified.

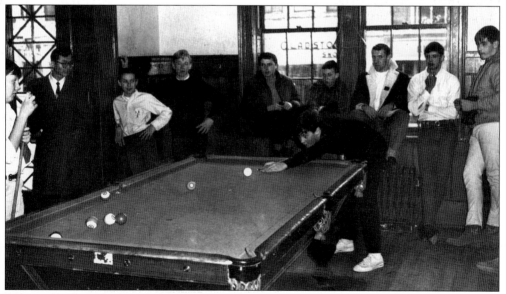

About to make a shot, pool player Ed Derosia is watched by his companions, who include Bill Warner, ? Warner, Chip Howe, Larry Guetti, Rick ?, and Frank Snow.

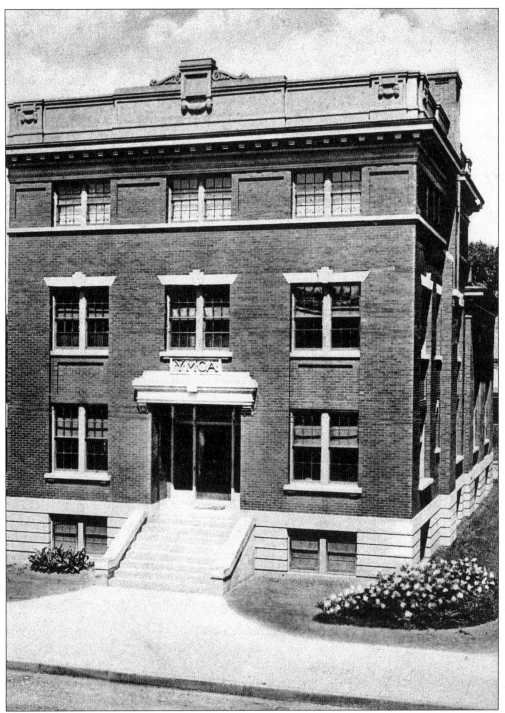

The Young Men's Christian Association building was erected at an initial expense of $25,000, besides the cost of equipment. Fletcher D. Proctor, governor of Vermont, dedicated it on May 14, 1907. The building was demolished and replaced by a Dunkin' Donuts.